ABSTRACT DESIGN
AND
HOW TO CREATE IT

AMOR FENN

With a New Introduction by
RICHARD M. PROCTOR

DOVER PUBLICATIONS, INC.
New York

This Dover edition, first published in 1993, is an unabridged repub-
lication of *Abstract Design: A Practical Manual on the Making of Patterns
for the Use of Students, Teachers, Designers and Craftsmen,* originally
published in 1930 by B. T. Batsford, Ltd., London, and Charles Scribner's
Sons, New York. The color plate, originally the frontispiece, now appears
on the inside front cover. A new Introduction has been prepared for this
edition by Richard M. Proctor.

Manufactured in the United States of America
Dover Publications, Inc., 31 East 2nd Street, Mineola, N.Y. 11501

Library of Congress Cataloging-in-Publication Data

Fenn, Amor.
 Abstract design and how to create it / Amor Fenn ; with a new
introduction by Richard M. Proctor. — Dover ed.
 p. cm.
 "An abridged republication of Abstract design: a practical manual
. . . originally published in 1930 by B.T. Batsford, Ltd., London, and
Charles Scribner's Sons, New York."
 ISBN 0-486-27673-2
 1. Repetitive patterns (Decorative arts) 2. Design—Technique.
I. Fenn, Amor. Abstract design. II. Title.
NK1510.F42 1993
745.4—dc20 93-16117
 CIP

INTRODUCTION TO THE DOVER EDITION

> . . . wherever there is ordered repetition there is pattern. Take any
> form you please, and repeat it at regular intervals, and you have,
> whether you want it or no, a pattern, as surely as the recurrence of
> sounds will produce rhythm or cadence.
>
> LOUIS F. DAY, *The Anatomy of Pattern*, London, 1897

Fashions change rapidly and our taste for pattern varies with the season, the economy and global events. Design changes tend to be cyclical; motifs that are popular this year may disappear for a time but two years hence emerge in another context, arrangement, stylization or coloration. However, one class of patterning is perennial and seems universally employed for furnishings, apparel and architectural surface treatment regardless of fashion's whim. That form is classical abstraction based on geometry, nature or both—the very subject of this excellent and long out-of-print book by Amor Fenn.

The intent of the author was to provide a practical manual for patternmaking by students, teachers, craftsworkers and designers. All of the basic tools in Chapter II are still available and in use. Even in this time of computers and photocopiers, many techniques such as rubbing down (pp. 16–17) are applicable to, for instance, textile print designers everywhere.

Fenn concludes with a short chapter detailing many reasons for and hints on the stylization of chiefly botanical forms. This final chapter also includes a remarkably succinct yet comprehensive discussion of color harmony (pp. 193–195). It may seem a bit arbitrary by today's trends but it provides a practical place to begin.

Certainly the heart of this book and its greatest gift is the marvelously proportioned diagrams that comprise most of Chapters III and IV concerning border treatment and allover textile patterns. Coco Chanel is credited with saying that elegance is simply the absence of vulgarity and in this context, at least, these diagrams are truly ele-

gant. Best of all, they are as instructional as they are appealing. The underlying networks, design construction and decorative variations are clearly evident in every plate.

I highly commend this book to designers of textiles, paper products, the printed page and patterned surfaces of every sort; to students of historic ornament; and finally to mathematicians, for geometry is fundamental to all it contains.

April 1992 RICHARD M. PROCTOR
 Chairman, Fiber Arts Program,
 University of Washington, Seattle

NOTE OF ACKNOWLEDGMENT

I AM indebted to my old friend Mr. Harry Napper for permission to reproduce his design, "Fair-field," as a frontispiece. The unit in this is wider than usual, and occupies the full width of the material, which is 31 inches.

The reproduction is therefore only a part of the design, which depicts the various forms of entertainment common to a country fair. These, with the interested groups of holiday folk, constitute the sole material. Humour is a conspicuous element, and though the episodes are to some extent realistic in rendering, it is something of a *tour de force* in that the sense of pattern is preserved throughout.

The extremely skilful arrangement on decorative lines would be more apparent had it been possible to reproduce a larger area of the design.

It is printed in eleven distinct colours, some of which are also employed as stipples and others are superimposed. It was produced by Messrs. G. P. & J. Baker, Ltd., by means of the surface machine. This firm were the first textile printers to use this method in England.

Acknowledgment is also due to Miss Dorothy Snow, the headmistress of the Art Section of the Goldsmiths' Training College, New Cross, and to Miss Bunnell, of the Handwork Section at the same institution, in affording opportunity to reproduce work executed by students in their respective departments; and last, but not least, to my one-time student, Miss Dora Bard, who is responsible for many of the illustrations in this work.

CONTENTS

ILLUSTRATIONS

EXPLANATORY DETAILS

ILLUSTRATIONS

xi

BORDER PATTERNS

TEXTILE PATTERNS

HISTORICAL EXAMPLES. TEXTILE PATTERNS, ETC.

HISTORICAL EXAMPLES : VARIOUS

 No. 1. GOLD EARRING, BYZANTINE.

 No. 2. GOLD RING, ASHANTI.

 No. 3. GOLD CHAIN, ASHANTI.

 No. 4. GOLD ORNAMENT, ASHANTI.

 No. 5. GOLD EARRING, BYZANTINE.

 No. 6. GOLD EARRING, ANTIQUE ROMAN.

 No. 7. GOLD EARRING, GREEK, ROMAN PERIOD.

 No. 8. GOLD EARRING, GREEK.

 No. 9. GOLD RING, ANGLO-SAXON.

 No. 10. GOLD EARRING, ROMAN.

 No. 11. BUCKLE, CELTIC.

 No. 12. GOLD EARRING, ANTIQUE ROMAN.

 No. 13. GOLD ORNAMENT, CELTIC.

 No. 14. PUZZLE RING.

HISTORICAL EXAMPLES: VARIOUS (*continued*)

HISTORICAL EXAMPLES: BORDER PATTERNS

ABSTRACT DESIGN

INTRODUCTORY

THE object of this book is to deal with elementary pattern and its construction. The design of structural work or formative processes is not dealt with, though experience will show that the underlying factors are much the same in all cases.

Early attempts usually fail through having too much variety. With painted ornament, usually a personal performance, more licence may be allowed, but a good deal of restraint is æsthetically essential to good decoration. An extremely simple unit may by its repetition give an elaborate effect of pattern. Students are advised to analyse patterns that appeal to them and endeavour to determine the factors to which the effect is due.

The desire to be original is an early obsession, but originality is a misapplied word, since we can only deal with that which has entered into experience—a more appropriate term is personal or individual—and this is the main quality that gives distinction to an artist's work.

Invention is involved in design to a certain extent, but rather in adapting and arranging than in evolving anything that is entirely new. At no time has anything been produced that had no resemblance to nature in some way or another, often remote certainly, and often curious and with symbolic significance; such strange combinations, for instance, as the Assyrian winged and man-headed bull, which were attempts to represent certain qualities in a symbolic way.

Repeating patterns are constructed on a geometric basis. The design may be frankly geometric in detail, that is, such as can

be directly executed by the mathematical instruments, or floral or other details not so obviously abstract may be employed, and in many cases the geometric structure on which it is built may not be directly apparent. In a perfectly free all-over pattern the geometric element may merely consist of the general line to ensure repetition; the unit may be planned on a rectangle, a square, or a diamond, and any further geometric element may not appear. In many patterns the dominant lines are obviously drawn with the aid of instruments such as those where the undulate line is employed either as a stem, or to define and emphasize shapes.

Good effects are obtained by grouping details into deliberate geometric shapes, such as the circle, square, or triangle, and these should be arranged so that the recurrence of them also forms pattern. The shapes may be rigidly adhered to, or they may be modified with the detail to disguise to some extent the plan on which the latter is arranged. As a general rule a design that is to be repeated indefinitely should when seen at a moderate distance suggest pattern in the dominant shapes which on closer observation are seen to be composed of smaller detail. The Persian design illustrated No. 344 is an example of this. The dominant detail is in the form of a conventionalized pink composed within the limit of a circle, and the general plan is that of the diamond.

Reference to the illustrations will show the influence and importance of geometry in design, and the recognition of this as the general basis and in some cases in the detail will be found a saving of time, and will avoid aimless floundering about, only to arrive eventually at the same point. It is desirable, therefore, that in practice a geometric structure should be the first step.

CHAPTER II

IMPLEMENTS AND THEIR USE

THE evolution of a design is a compound performance, con sisting in the first place of the idea, and in the second of its methodical working out as a concise detail suitable for the process of reproduction for which it is intended. This methodical side of the work involves careful attention to drawing and arrangement, and is necessary if the design is to be of any particular use.

Although the idea may be a matter of impulse, the final drawing of any pattern intended for some process of reproduction must conform to the conditions imposed by the process; and this drawing which is a working detail must be mathematically exact with regard to dimensions and its intended repetition. The meticulous procedure essential to a working drawing is generally foreign to the impulse which is so desirable in the inception of a design, and possibly a great deal of the original feeling may be lost in the necessarily protracted period of working out; but the endeavour should be to preserve this feeling throughout, and so retain the virility of the design in its final expression.

There appears to be an inherent superstition that all drawing to be really artistic must be freehand, and that the aid of mechanical implements should not be sought. Practically it does not matter how a drawing is done if only it is well done.

It is not immoral to rule lines that are intended to be straight, and the desirability of doing so is particularly apparent when a number of parallel lines are associated, as in borders and framings.

The angles of enclosed shapes, such as squares, rectangles, and polygons, should be correctly formed, and this is of vital importance when such shapes are bordered by a number of lines.

Where circles, parts of circles, or ovals are used, these can be more accurately drawn by means of instruments.

Work of this nature· is technically known as "Geometrical Drawing," which may appear to many as appalling in its scientific suggestion; but it will be found in practice that very little knowledge of geometry is involved, and that most of the desirable results may be attained by easy methods and the use of very few instruments.

The consideration of these instruments does not seem to be common in early training, and few students appreciate their usefulness.

The most generally useful drawing-board for design is 30 in. by 22 in., known as an Imperial board.

It is as well when making any drawing to pin the paper properly on to the drawing-board—that is, at the four corners. Broad-headed pins are best, and should be pressed well in, so that the paper is held by the pressure of the head and not merely by the actual pin. They can be readily removed when necessary if levered up with the blade of a knife. In pinning the paper down make a practice of placing it with its edges parallel to those of the board, and not allow the paper to overlap the board, as this interferes with the accurate use of the T-square, and is in every way undesirable. If the paper is larger than the board, it should be trimmed to the required size.

For drawing horizontal lines the best implement is the T-square, so called because the head is at right angles to the drawing-edge. The object of this head, which is deeper than the blade, is that it can be moved along the edge of the drawing-board against which it engages. The T-square should have a bevelled edge, as this helps accuracy in drawing, and it should be long enough to reach the long way of the board—if longer it is all to the good, as the larger square is heavier and steadier, and therefore more accurate. The head should be kept true to the edge along which it slides. The upper edge should be used solely for drawing and not for cutting. The general impression appears to be that when a drawing has to be trimmed, the knife should be used on this side, with the inevitable result that the truth of the drawing-edge is impaired. When trimming is to be done, lines should be drawn where required, and the back of the T-square used to guide the knife if no other form of straight-edge is available.

The blade of the **T**-square is usually tapered, at least in the better sort, and therefore the back-edge, not being parallel to the front, is not at right angles to the head. But for trimming this edge can easily be adjusted to the drawn lines by shifting the drawing. The **T**-square should be held firmly in position by the fingers of the left hand so that it cannot move, and care should be taken in using the knife that it is held parallel to the cutting-edge all the way, pressed through the paper at the start of the cut, and drawn slowly and firmly through the length of the

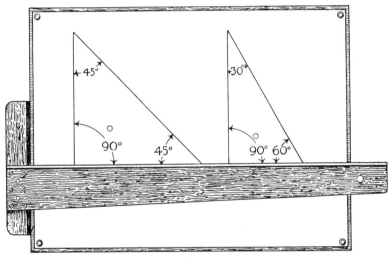

No. 1.

line. If improperly held the knife may ride upon the **T**-square and injure it, or even come into unpleasant contact with the fingers.

The **T**-square is generally used from the left side of the drawing-board, in fact, this is inevitable if the square is tapered, and as already stated is the most workmanlike and convenient implement for drawing horizontal lines.

While drawing such lines, care should be exercised to keep the hand in the same attitude throughout, otherwise the angle at which the pencil is held may vary, and the result will be a

curved instead of a straight line. Lines of slight curvature are sometimes deliberately ruled in this way when required. Lines at right angles to the horizontals may be drawn by using the T-square on the bottom edge of the board, but only if the latter be true; few boards, except those for architectural or engineering drawing, are to be relied on, and the vertical lines are best drawn by means of the set-square.

The set-square is triangular in shape—the two most commonly used are the 45° and the 60°. One of the properties of the triangle is that the sum of its angles is 180°. The 45° set-square has two angles of 45° and the third a right angle or 90°. The hypotenuse, or side opposite the right angle, is thus the diagonal of a square. The 60° set-square has one angle of 60°, one of 30°, and one of 90°. For pencil-drawing the best set-squares are of celluloid, as being transparent, the position of the required line is more readily seen, furthermore, they are thin and do not wear down the pencil-point to any great extent; but they should not be subjected to heat of any kind or they may warp, or otherwise suffer. Set-squares are also made of wood, the better sort of mahogany with bevelled ebony edges. These are the most suitable when ruling in ink, and should then be used with the bevelled side downwards, as this keeps the ruling-edge clear of the paper, and there is less chance therefore of the ink running and blotting the drawing.

Set-squares are more useful when large, 12 in. high is a very useful size.

Uses of Set-Squares.

It is obvious that as both of these set-squares have an angle of 90° either of them can be used to draw lines at right angles to horizontal lines by the simple expedient of placing the base edge on the T-square, and, as already stated, this is the most accurate method of drawing vertical lines.

Uses of 45° Square.

The 45° square is employed in defining the mitres of square and right angular shapes. If for instance a square or rectangle is to have as a border a series of lines, these need only be spaced

on one side, and a line at 45° drawn from the angle. From the points where this line which forms a mitral angle intersects the border lines, these are carried along the adjacent side, and by

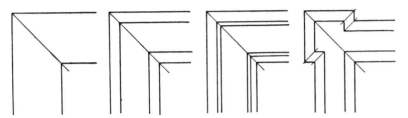

No. 2. Use of 45° set-square in returning lines at mitral angles.

repeating the process at the remaining angles the border is completed.

If carefully done this is quite accurate, and saves time in measuring.

Again, if a surface has to be divided into squares, this can be readily accomplished by marking on a vertical line a number of points, the distance between them being the length of the side

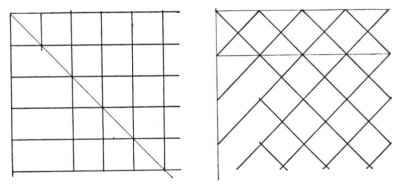

No. 3. Use of 45° set-square in dividing surface into squares.

of the squares required, and drawing horizontal lines through them. The other dimensions are determined by a line at 45° to the horizontals. At the points of intersection verticals are drawn, which complete the divisions into squares.

The 45° set-square is useful in the formation of the octagon. Assuming the length of one side to be given, and that this is horizontal, the set-square can be employed to give the adjacent sides. The length of the original line should be measured off on these and the vertical sides drawn. By similar procedure the other sides are obtained.

When the height of the octagon is given, the figure may be constructed by striking a circle the radius of which is half the given height and drawing tangents by means of the T-square and set-square. These tangents form the sides of the octagon.

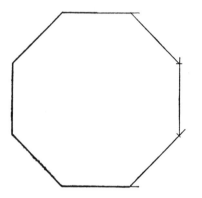 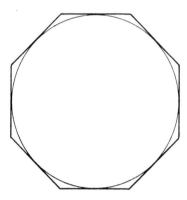

No. 4. Octagon constructed by 45° set-square on given side.

Octagon constructed by 45° set-square outside circle.

The irregular octagon, that is one which has four sides equal but dissimilar in length to the intermediate sides, which are also equal, can be drawn in precisely the same way by measuring the two lengths alternately as the figure is drawn.

USES OF 60° SET-SQUARES.

Equilateral triangles can be drawn with the 60° set-square and extended indefinitely, also the six-sided figure known as the hexagon, which consists of six equilateral triangles, can be formed with the 60° set-square in precisely the same way as described for the octagon. Lines drawn with the 60° set-square at equal distances with similarly spaced lines crossing them form a diamond

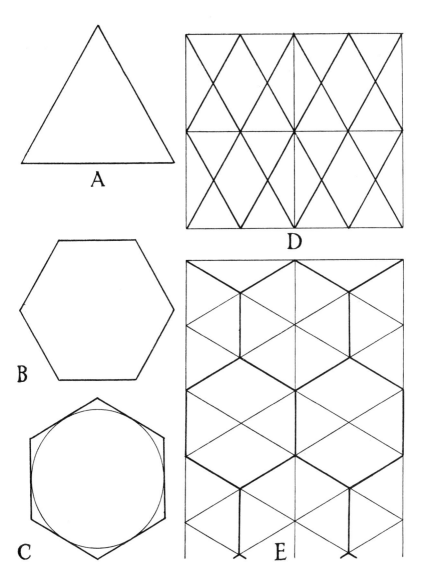

No. 5. A. Triangle constructed by 60° set-square.
 B. Hexagon constructed by 60° set-square on given side.
 C. Hexagon constructed by 60° set-square outside circle.
 D. Diamond all-over constructed by 60° set-square.
 E. Hexagonal all-over constructed by 60° set-square.

pattern. The spacing and points of intersection are first deter-
mined by horizontal or vertical lines. In a similar way a hexagonal
pattern can be produced. Both the diamond and the hexagonal
setting out form the foundation of a number of all-over patterns,
and in some instances are emphasized till they become a feature

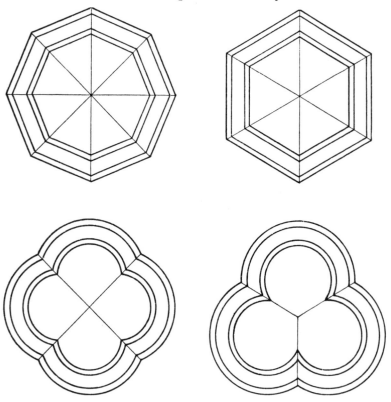

No. 6. Mitral angles of polygonal and circular forms.

of the design; in this case the diamond is known as a trellis pattern
and the hexagonal as a net.

Mitral Angles.

A mitral angle is the bisection of the angle at which lines meet.
Obviously this is only an angle of 45° in the case of the square

or rectangle. The mitral angles of hexagons, octagons, or any polygon having an even number of equal sides, can be obtained by drawing the diagonals.

The mitral angles of the enclosed curved form known as the trefoil is determined by joining the point where the arcs intersect to the centre point of the opposite arc. That of the quatrefoil is found by joining the opposite points of intersection of the adjacent arcs.

To find the mitral angle of concentric curves meeting parallel

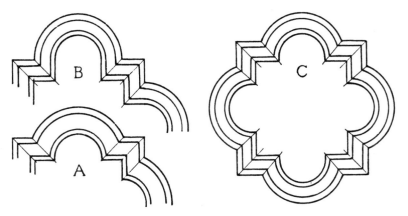

No. 7. A. All angles 45°. Result border lines not uniform in spacing.
 B. All angles 45°. Border line uniform in spacing; even more unsatisfactory.
 C. Angles of square only 45°. Width of border measured from outer line and mitral angles determined at meeting of curved and straight lines.

straight lines, the safest plan is to mark the total width of the border from the outer lines, draw the curve and corresponding straight line at this distance, and join the point where they intersect to the outer angle.

Borders of circular shapes are obviously formed of concentric circles. Borders of elliptical shapes are slightly more complicated due to the figure being struck from more than one centre. To ensure uniform spacing and perfect continuity of the border, lines must be drawn through the centres of the major and minor

axes to determine where the arcs of which the border is composed should meet. Similar procedure is necessary if a number of parallel lines are used in a curve of double flexure.

MEASUREMENT AND DIVISION OF LINES.

For measuring, some form of rule divided into inches will be found useful, and since there is considerable variation in these,

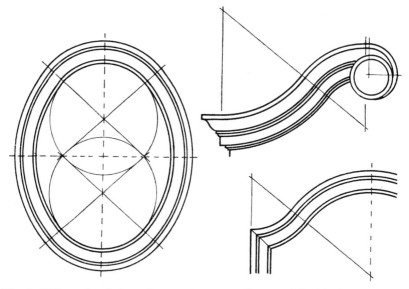

No. 8. Ellipse struck from four centres. Curves of double flexure.

particularly in the cheaper kinds, it is desirable to obtain one that can be relied upon.

Scales either in ivory or boxwood can be depended on, but for ordinary measurements the most dependable rule is that used by engineers, which is of steel, and not easily affected by wear or other conditions.

Measurement by such means is often found in designing to be insufficient and cumbersome. For purposes of more accurate measurement one of the most useful instruments is the dividers. This is provided with two sharp points, which enable dimensions

to be repeated with great accuracy, and is particularly useful in scale-drawing.

Of still greater accuracy is the small variety known as spring-dividers. This is adjusted by a screw which gives very delicate control, with the added advantage that once so adjusted they cannot change until the screw is manipulated.

If, for instance, it is required to indicate a repeated measurement of, say, $\frac{1}{4}$ in. along a line, the spring-dividers can be set to this dimension from a rule and the points pricked through the paper; uniformity of spacing is thus ensured, which is not readily achieved by any other means. As the points are fine, generally needle-points, they will not be visible on the completed drawing.

No. 9. Ordinary and spring-dividers.

Divisions that are neither inches nor convenient fractions of them may be found by trial, but this is a tentative method, and may entail the waste of valuable time.

To bisect any line, either of the set-squares can be used; and obviously the two parts can be again bisected, and so on *ad infinitum*. The method is indicated in the diagram. This is only applicable when an even number of equal spacings is required, and only in the sequence 2, 4, 8, 16, 32, etc.

If an odd number of divisions is required, the procedure is as diagram No. 11.

No. 10. Use of 45° set-square in division of band.

This method is not only accurate if carefully executed, but involves little time. It consists of drawing lines which must be

parallel to each other at each extremity of the line to be divided. To ensure their being parallel it is as well to use a set-square, and the 60° is most suitable. On these lines the required number of divisions are marked off, any reasonable size will do, and the points are joined. The intersections on the original line give the spaces required.

Three varieties of compass are commonly used—the smallest, for fine small work, known as spring bows; the medium size or bow compass; and the large size, which can be used as dividers, has separate adjustable parts, a divider-point, a pencil, and pen, and a lengthening bar for larger circles.

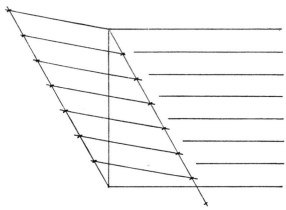

No. 11. Method of dividing a band into a number of equal spaces.

The pen compass can be adjusted to give lines of different widths, thick or thin as required.

THE RULING-PEN.

The ruling-pen is similar to the pen compass in form and method of adjustment for different widths of line. This is used for ruling with a T- or set-square. It should be held upright and with the blades of the nib parallel to the ruling-edge. If the angle of the pen is altered the line may be curved instead of straight. The extremes of thick and thin lines of which the pen is capable will soon be discovered with practice. If screwed too tight the

ink will not flow; if the blades are too wide open, or filled too full, the pen will flow too freely and the ink will blot the drawing. For a thick line which is beyond the safe limit to which the pen can be adjusted, the best way is to draw two lines giving the width

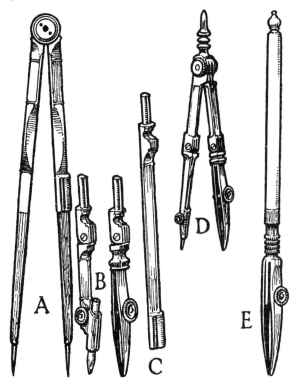

No. 12. A. Large dividers.
 B. Adjustments for pencil and pen.
 C. Lengthening bar.
 D. Medium size bow-pen.
 E. Ruling-pen.

and to fill in between them. The pen should never be dipped in the ink, as the width of line is increased thereby, the ruling-edge is made inky, endangering the drawing, and the ink is more likely to flood. An old brush or ordinary nib can be kept for the purpose of filling the pen.

For pen-drawing particularly for reproduction a solid black ink is essential. Ink can be obtained in many colours, and for some purposes coloured inks are extremely useful. Brown may be very effective used in conjunction with colour; it should, of course, be waterproof.

Lines that define form necessarily vary according to the scale of the drawing, but thin lines are as a rule weak and ineffective. Generally speaking, a thick line will give a richer effect, but so much depends on the nature of the drawing, and to determine the thickness of line is a matter of experience.

Tracing-Paper.

For the repetition of any but geometric detail, tracing-paper will be found indispensable. Tracing-paper, which is transparent, should be pinned over the detail it is required to repeat. The lines will be readily seen through, and an exact replica can be made by drawing over them. The tracing should be as carefully and completely done as if it were the finished drawing. If a unit has to be reversed in the repeat, the tracing-paper can be adjusted to the required position pencil side downwards—in fact, reversed— and the pencil lines set off or transferred by rubbing over them with the back edge of a knife-blade. Care must be taken that the tracing-paper is in the correct position and does not shift. The best plan is to hold it down with the fingers and rub with the knife in strokes away from where it is being held. It is necessary to make sure that all the lines of the tracing receive the same attention. The best tracing-paper for the purpose is white un-glazed, and the tracing should be made with a fairly soft pencil, preferably a B.

When the unit has been thus reversed, a further tracing will be necessary to obtain a replica of the original attitude. This can be done by pencilling the tracing on the reverse side, or by making a new tracing from the transferred result.

Another method of repeating a design is by means of transfer-paper, which is prepared on one side so that a set-off can be obtained. Carbon paper used in typewriters and manifold note-books should never be used, as the lines cannot be easily erased,

and owing to their greasy nature resist any colour that may be applied. A suitable transfer paper can be quickly and easily prepared. It should be thin, tissue-paper is about the best for the purpose. One side of the paper should be thoroughly blackened with stumping chalk or conté crayon, but care must be taken in using the latter not to tear the paper. The chalk should be well rubbed in until a line can be set off by ordinary pressure of the pencil without any blackening of the general surface of the drawing. Finally, it should be trimmed so that the edges are true.

A hard pencil is most suitable for setting off the drawing by means of transfer-paper, though transfer points, which are part of the equipment of a drawing office, may be used, and these have the advantage that they do not require sharpening.

It should be borne in mind that every time a tracing is worked over there may be a tendency to get off the original line, and when the transferring is by means of a pencil-point the line may be slightly altered or thickened; this probably accounts for the common belief that much is lost in the tracing, but there need be no loss if the work is done carefully throughout—it depends on the worker. If the tracing is executed in ink there is less tendency to deviation, as the original lines remain distinct.

The most accurate results are obtained by rubbing down, as already described, as each transfer is from the same pencilling; and this method is commonly used by professional designers.

If the work is carefully done, a clear transfer will be the result, and the drawing can be completed in any medium that is thought desirable. There should be no necessity for pencilling over, as this adds to the possibility of alteration of the original. That the efficiency of tracing-paper and the accuracy resulting from its proper use is appreciated by professionals should suggest to students of design the advisability of becoming acquainted with its possibilities.

THE TREATMENT OF THE BORDER

APPRECIATION of the decorative value of the border seems to be universal, for it is to be found in every period from the very

earliest times. It appears in Egyptian and Assyrian art, is freely used in the decoration of Greek vases, and, to come down to our own time, in much of the pottery and china ware in use to-day.

In metal work it has always been popular, whether engraved, in relief, or enamel. Embroidered or woven, the border may decorate the hem of a garment or serve to frame a carpet.

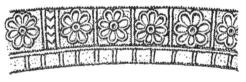

No. 13. Borders of royal garments. Assyrian sculptures. (*British Museum*, 885–860 B.C.)

The early illuminators made considerable use of it, and to this its modern employment as framings for advertisements, title pages and the like may be attributed.

In architecture it is used as a decoration to the facia, and is similarly employed in wood and in cabinet work.

No. 14. Illumination. Early fifteenth century.

The border may be used to divide surfaces such as walls and ceilings, and as a framing to enclosed spaces. In the latter case it is pseudo-structural, and is analogous to mouldings similarly used. The structural suggestion, therefore, should have some influence on the design, and the principles involved in the decoration of mouldings would be applicable to the border. The decoration or enrichment of mouldings—generally an alternation of two comparatively simple units—is almost invariably in contrast to the direction of the mouldings, that is, the centre lines of the usually symmetrical units are at right angles to the direction.

The detail may be geometric or floral, and should be in contrast to the decoration of the enclosed area. Owing to the frequent repetition elaborate or varied ornament is unsuitable, that is, the interest of the individual units should be slight, as the real interest is achieved by their repetition. It is obvious that a border used as a framing, in which a unit is repeated at regular intervals, should be divided in such a way as to avoid the mutilation of a unit. On circular shapes, as for instance round the edge of a plate, this can be easily done by dividing into six or eight parts by means of the set-squares and then subdividing as required.

No. 15. Border or frieze detail on rails. Wood-carving on chair. French, late sixteenth century.

For rectangular shapes, a divisor common to height and width is desirable. This may be difficult at times if the area to be framed is given, though the solution may be in adapting the width of the border to the unit. If this cannot be done, the divisions of the two dimensions should be made as nearly alike as possible; there may be only a minute difference, which would not be apparent in the final work.

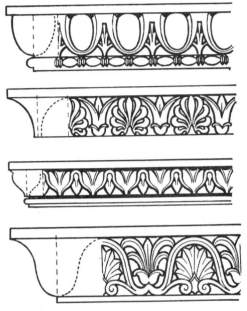

No. 16. Detail of Greek mouldings.

Having obtained the divisor the unit of the design should be drawn, and if the detail is purely geometrical — such as can be readily and accurately repeated by use of the set-squares and instruments, the drawing can be completed. For the repetition of more complex detail tracing-paper will be found indispensable.

The unit of borders used as frames enclosing squares or rectangles will not always go round the corner satisfactorily without some modification at the angles.

Many details based on the square will require little or no adaptation—the chequer or chess-board pattern is an example.

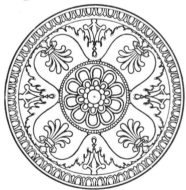

No. 17. Border detail; bent to circle. Italian Renaissance. (*S. Michele, Venice.*)

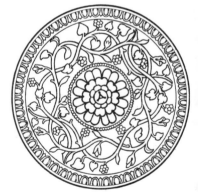

Though effect of detail is continuous, two branches are employed: an example of consistency in growth.

Interlacements will occasionally carry round without alteration, but generally have to be modified.

Simple key patterns, patterns based on the evolute line, which is really a rounded version of the key, and patterns based on the undulate line, may be continuous if the detail is purely geometric, or if there is no suggestion whatever of growth.

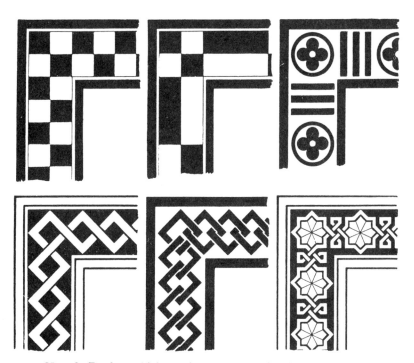

No. 18. Borders which continue round angle without change.

However conventional the detail may be, if there is any suggestion of growth—if stems bear leaves and possibly flowers—the condition is imposed that the growth should be consistent throughout, and this is the more essential if the detail is based on a natural type.

The tendency of plant-growth is progressive and towards the light, and it would be inconsistent to make the growth in reverse

directions on the same branch, or to provide two stems to a single flower.

A satisfactory method consistent with natural growth is to make the design bi-symmetrical, the two stems starting from the

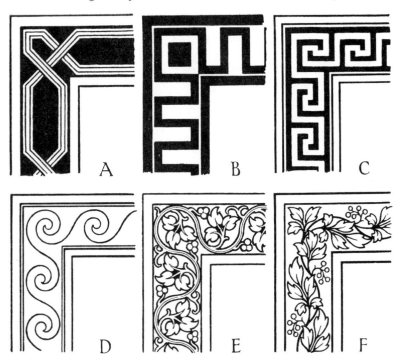

No. 19. A, B, C. Border detail involving slight alteration at angles.
 D. The wave or evolute, continuous without change.
 E, F. The undulate, involving slight modification.

base, growing upwards, and meeting or engaging at the top of the border.

Or the design may consist of a repeated unit, and will generally require some modification at the angles; the examples illustrated suggest how this can be done.

Even in the case of patterns which can be continuous, a bi-symmetrical arrangement is sometimes desirable. Illustrations

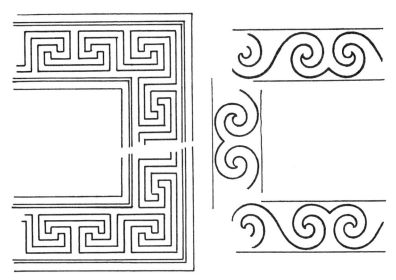

No. 20. Treatment of centres, starting and meeting.

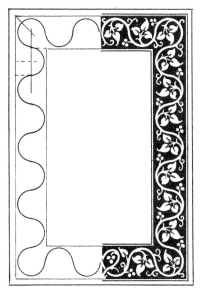

No. 21. Undulate stems reciprocally arranged.

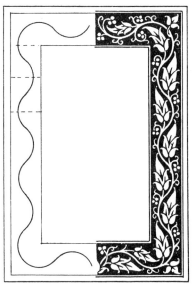

Consistency of growth in start and termination.

are given of the key and evolute line starting at the base and meeting at the top.

The corners of a frame should be the strongest part, the detail should therefore occupy the shape to such an extent that the framing lines are not doing the work of holding the design together. When the border is based on the undulate line this is particularly necessary, as the increased curvature at the angles as the stem turns the corner will look weak, unless the detail gives emphasis to the straight lines forming the angles.

ACCENTUATING THE CORNER SQUARES AND PANELS.

Another treatment is to accentuate the corner by using a separate unit as shown. Here the inner framing lines are carried

No. 22. Angle treatments where border detail cannot be continuous.

through to meet the outer, resulting, if the frame is the same width all round, in squares at the four angles and four panels between. The squares can be occupied by rosettes or pateræ; the side panels should preferably be bi-symmetrical, suggestive of pilasters; and those at the top and bottom should be frieze-like in character, in recognition of the horizontal position. Each panel should be complete in itself, with no suggestion of continuity as in the case of the unbroken border.

The design of a border does not necessarily involve the repetition of a unit—it may be a free composition to occupy the given space, and should be complete in this respect.

The design may consist of a freely arranged growth of stems with appropriate leaves and flowers. For the design to be satis-

factory the licence of nature must be subordinated to a decorative effect. The flowers and leaves may either be grouped in dominant masses which must balance each other and form good shapes, or be uniformly distributed. Both arrangements can be effective,

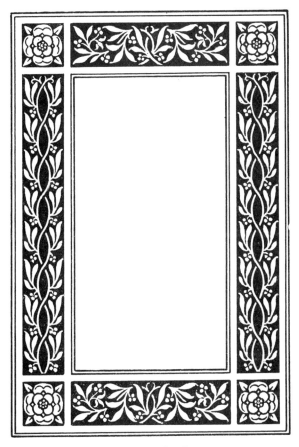

No. 23. Border broken into panels with corners accentuated.

but the possibilities of design are endless, and the elements that can be employed are numerous. The human figure, animals, insects, in fact any natural or symbolic form suitably treated, may be appropriate to the design.

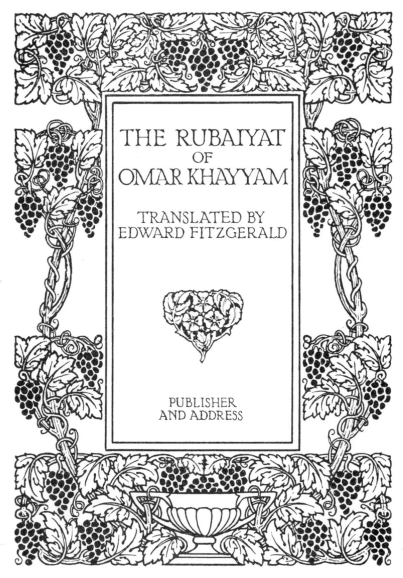

THE RUBAIYAT
OF
OMAR KHAYYAM

TRANSLATED BY
EDWARD FITZGERALD

PUBLISHER
AND ADDRESS

No. 24. Design for title page. Symmetrical arrangement. Formal character of detail sufficiently in harmony with boundaries of page to render external framing lines superfluous.

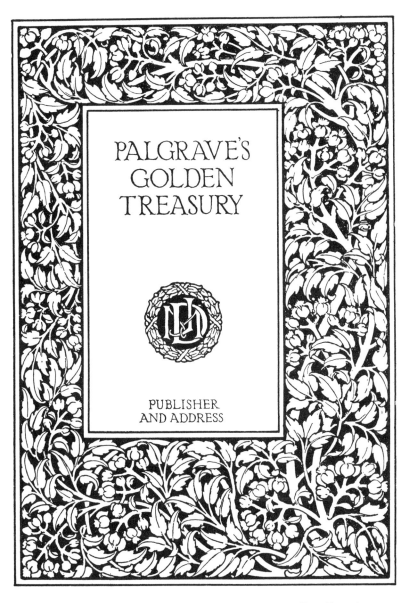

PALGRAVE'S
GOLDEN
TREASURY

PUBLISHER
AND ADDRESS

No. 25. Design for title page. Border varied in width. Detail conforms to diminished spaces preserving a uniform background.

Among typographical examples are title pages of books, mainly in black and white. These may be symmetrical in arrangement, or varied throughout; there is no hard and fast rule. The lettering is an essential part of the design, and the desirable

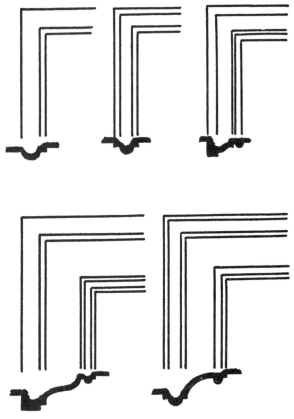

No. 26. Bordering lines suggested by mouldings, sections of which are shown.

procedure is to set this out effectively. It will then be seen how much of the area can be utilized for any ornamental setting. This of course applies to all cases where a statement in lettering is the *raison d'être* of the work, such as many posters and advertisements of various kinds.

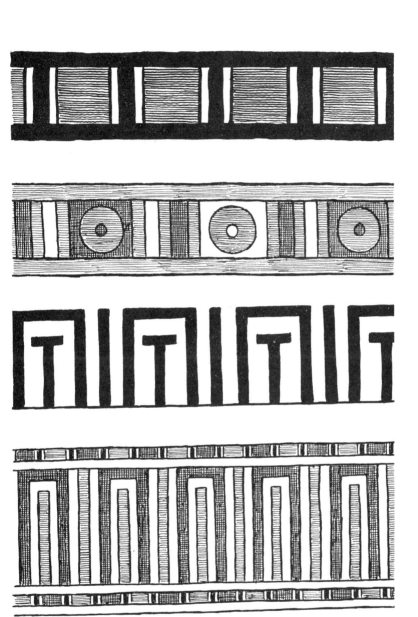

No. 27. Painted details from mummy cases. Egyptian. (*British Museum.*)

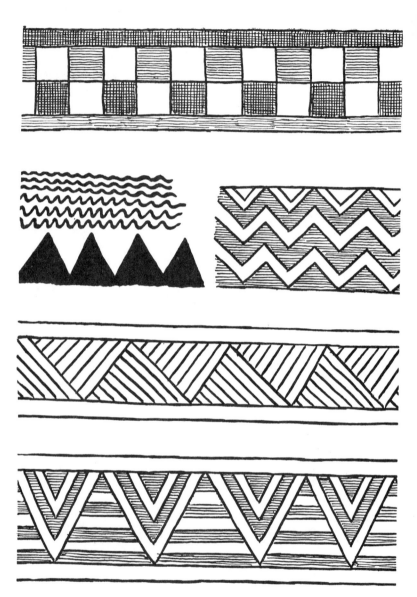

No. 28. Painted details from mummy cases. Egyptian. (*British Museum.*)

Borders generally require enclosing with subsidiary borders which serve to define them more effectually. Such borders may merely consist of narrow bands, or association of lines, and a good proportion for them is one-sixth or one-eighth of the total width of the border.

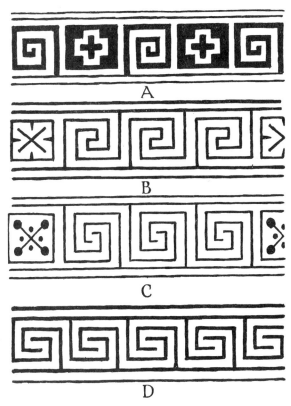

No. 29. Painted details from Greek vases.
A, B, and C. Interrupted key borders.
D. Continuous key border.

Where borders are employed as framings, the need for the subsidiary border is generally more insistent, as they really perform the same function to the enclosed area as structural frames to panels and pictures, and are analogous to mouldings. Designers

of structural work are well aware of the importance of mouldings and the effects of their use. Although these are in relief, an important factor in the effect is the spacing of the various members; for instance, the obvious repetition of the same dimension is to be avoided. This is even more important in borders which are

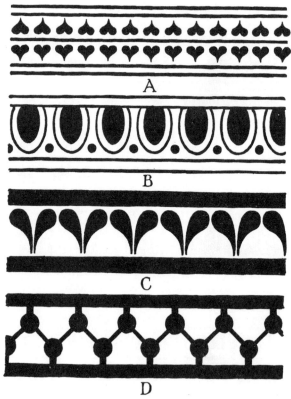

No. 30. Painted borders from Greek vases.
B and C. Suggestive of carved detail of mouldings.

rendered in the flat, and consequently not affected by light and shade. There should therefore be contrast in the width of the subdivisions—the wider bands being separated by extremely narrow ones, and no two bands in juxtaposition being of the same width.

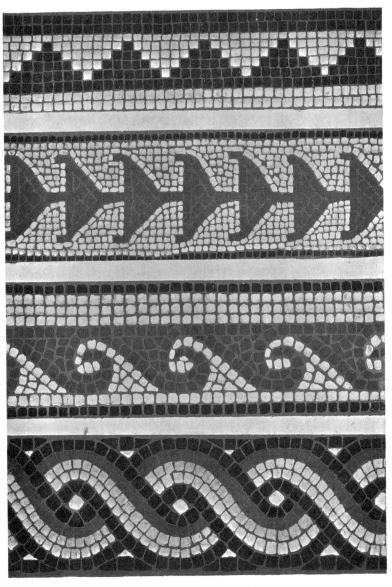

No. 31. Roman mosaic.

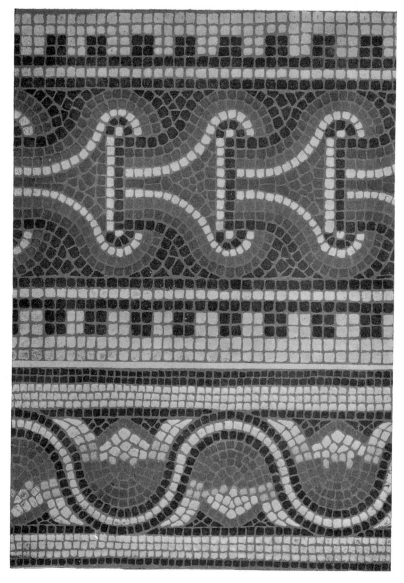

No. 32. Roman mosaic.

THE UNDULATE LINE.

From very early times the undulate has been universally employed. While preserving its continuity, the flowing line is susceptible to considerable variation.

It is a matter of reasonable conjecture that it was suggested by the facility with which metal drawn out into wire could be bent, and the conjecture is supported by the fact that from the earliest times jewellery has been fashioned in this way. A similar result would be obtained with moist clay rolled into threadlike lengths, and it is possible that the use of these in the decoration of early pottery was really imitative of metal wire. The flexible curves in painted decoration may also have been due to the same influence.

No. 33. The undulate line as a border. Roman.

The same flexibility of material characterizes the wrought ironwork of all periods; though much larger in scale, this is comparable to jewellers' filigree in the scroll details that result from the direct and legitimate use of material in both cases. Illustration No. 37 gives examples of early Italian ironwork made up of comparatively thin and small scrolls united by strips forming ties or collars, characteristic of much Italian work in this material. The detail of the grille of the Scala monument Verona is geometric in arrangement, and the quatrefoil of the filling is happily accentuated by the addition of leaves in the vertical borders. The ladder detail in the centre of the quatrefoils is the device of the Ducal family.

The tools used in any craft are bound to influence design to a certain extent. The technique of wood-carving differs considerably from that of stone.

An important tool in wood-carving is the gouge; the cutting-

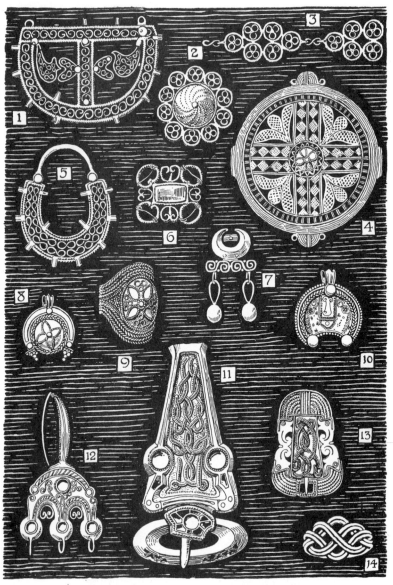

No. 34. Filigree jewellery. (*British Museum*.)

1. Earring. Gold. Byzantine. Width about 1¾ in.
2. Ring. Gold. Ashanti.

[*References continued at foot of opposite page.*

No. 35. Border on vase. Roman. Found in the Thames.
(*British Museum.*)

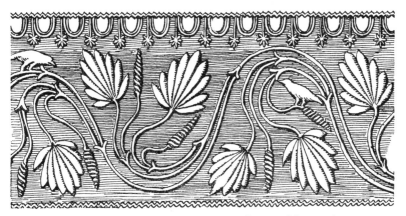

No. 36. Border of Gaulish vase. (*British Museum.*)

3. Chain. Gold. Ashanti. Link about $1\frac{3}{8}$ in.
4. Gold ornament. Ashanti. Width about $2\frac{1}{2}$ in.
5. Earring. Gold. Byzantine. Seventh century. Width about $1\frac{1}{4}$ in.
6. Earring. Gold. Set with green stone. Antique Roman. Width $\frac{3}{4}$ in.
7. Earring. Gold. Greek (Roman period). Width about $\frac{5}{8}$ in.
8. Earring. Gold. Greek. Third or fourth century. Width about $\frac{5}{8}$ in.
9. Ring. Gold. Anglo-Saxon.
10. Earring. Gold. Roman from Egypt. Width about $\frac{7}{8}$ in.
11. Buckle enriched with gold and set with glass. Celtic. Found Kingsfield, Faversham. Length about $3\frac{1}{2}$ in.
12. Earring. Gold. Antique Roman. Width about $1\frac{1}{4}$ in.
13. Gold ornament. Celtic.
14. Gold puzzle-ring.

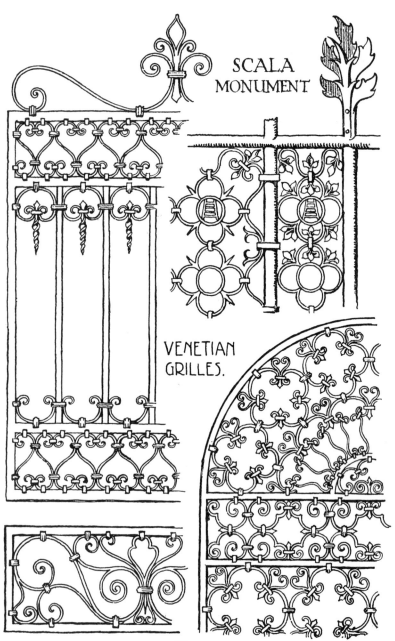

SCALA
MONUMENT

VENETIAN
GRILLES.

No. 37.
40

edges are generally arcs of circles, therefore the workman has only to choose the particular tool that will serve his purpose for the moment.

Curves larger than the gouge allows are the result of a series of cuts, and probably to obtain the desired line, with gouges of different curvature.

Gouges are also of various sizes. With any gouge, the carver, accepting the limitations of the tool, can by repeating the same curve produce a pattern which is geometric, as for instance the so-called thimble-work which appears to such an extent in Jacobean wood-carving.

No. 38. Geometric detail result of gouge wood-carving. Jacobean.

The influence of the gouge accounts for the geometric character of much of the simpler detail in wood-carving. The comparative facility with which such simple and satisfactory effects could be produced naturally led to its exploitation. Its execution did not require an extremely skilled hand, but could be entrusted to ordinary craftsmen. In the later English Renaissance the enrichment of mouldings was the work of carvers trained for the purpose, while the more important decorations were the handiwork of carvers of greater skill and initiative, whose time was too valuable for the monotonous and in the main purely geometric work of decorating mouldings.

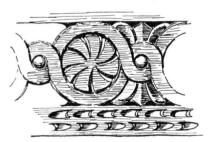

No. 39. Geometric detail result of gouge wood-carving. Jacobean.

If a design is to be realized in some material, the tools and the process employed are important factors, and the more these are understood and appreciated, the nearer the designer will get to a direct treatment for the material in question,

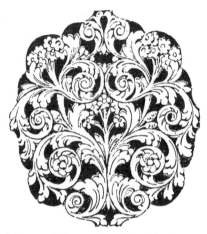

No. 40. Oak-carving. Flemish. Seventeenth century.

Pierced work. Design controlled by consideration of durability.

and consequently the better and more economical will be the result.

This is one of the reasons why much of the old work is so satisfactory. The early craftsman not only produced but designed his work, though doubtless the design was largely a matter of transmitted tradition; but he did not attempt work which did not arise quite naturally from the material and manner of working. The field of possibilities was considerably widened at a later period when the professional designer came into being, but often at the expense of the simple directness of the earlier work. The change was, however, stimulating, and in the main the craftsman responded, and skilfully devised means of doing apparently impossible things.

At the present day the old system would be inadequate to supply the demand. Even in the past division of labour was found essential, and workmen in the same craft were chosen for their special facility in certain phases of the work.

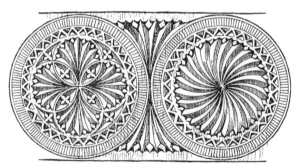

No. 41. Swedish chip-carving. Direct result of tool.

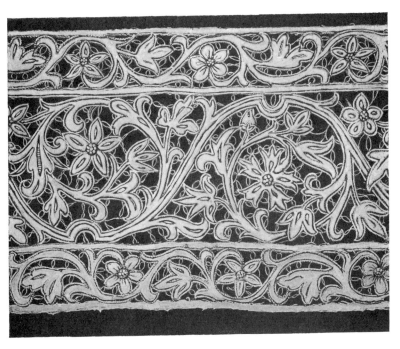

No. 42. Cut linen. Italian. Sixteenth century.

The professional designer of to-day is expected to know all the technical details of the craft for which he designs, and the craftsmen are skilled hands to carry out his ideas on an economic basis—naturally commensurate with the market value of the work produced.

The craftsman left to his own devices did not always keep strictly within the ordinary limitations of his craft; at times his ambition to show his skill led to results remarkable for workmanship rather than good taste. For instance, the flexible character of the design for cut linen illustrated would not have been adopted had the material and working been rightly considered.

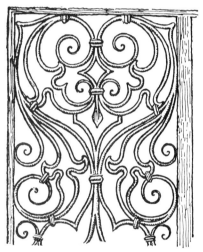

Even in early times there was a tendency to put a strain on material. Mosaic, for instance, would, from the square form of the tesseræ, most directly result in squared patterns, but the worker delighted in difficulty, and very often sinuous lines and rounded forms were used. Human and animal forms were represented, and even effects of light and shade attempted, and this certainly is an undesirable treatment for mosaic unless used with great restraint.

No. 43. Wrought ironwork. Leaf-like forms. Result of flexibility of material. Italian. Seventeenth century.

Forms readily made in one material were often imitated in another less suitable. At the same time, imitation is not always to be deplored. It is probable that the acanthus foliage of the Greeks was derived from the anthemion ornament, and that the latter was a rendering in stone of the earlier painted ornament. The original painted form was merely a suggestion, and the treatment in relief from it quite legitimate; in fact, it was an artistic creation of great beauty, sculptured with a fine appreciation of material, and as such has influenced subsequent art.

The smith when he fashioned his iron into the outline of leaves was obviously imitative, and desirous of doing something different

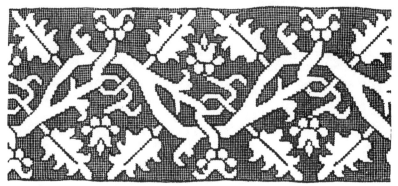

No. 44. Needlework border. Spanish. Early sixteenth century.

from the traditional scroll-work; he was, however, justified by the fact that the flexibility of the material readily lends itself to such a form.

The influence of material on design is evident in the inevitable squaring of form in cross-stitch embroidery; for example, No. 44,

No. 45. The undulate line as a stem with branching scrolls. Roman: stone-carving.

which consists of conventional floral detail expressed in the natural linen, the background only being worked.

No. 46. Ivory carving. Byzantine. Tenth century.

No. 47. Romanesque stone-carving.

No. 48. Details of Gothic carving.

48

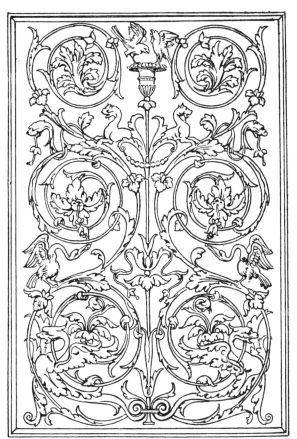

No. 49. Italian Renaissance panel composed of undulate stems
bi-symmetrically arranged.

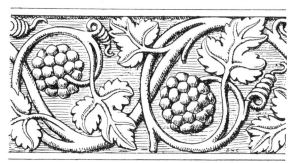

No. 50, Wood-carving. English. Early seventeenth century.

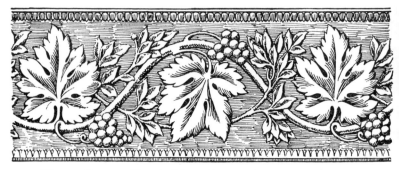

No. 51. Repoussé band. Silver. English. Eighteenth century.

DETAILS OF BORDERS.

Many designs of borders purely geometric in character are universal, being found in Savage, Classic, and Eastern Art. This may be due to influence, but it is equally probable that they were spontaneous productions.

For instance, the Fret ornament, conspicuous in Greek decoration, also occurs in Chinese and Japanese work. It may consist of one or more bands, and is labyrinthine in form. In Mohammedan and Celtic Art, interlacing of the bands is invariable; but the origin of the various patterns may reasonably be attributed to a local recognition of geometrical formation.

In Fret patterns, as a general rule, the best results are obtained when the intervals are of the same width as that of the meandering band.

The following diagrams are arranged in progressive order from the simplest division of a band. It is assumed in each instance that the width of the border is given. Each border pattern has subsidiary borders, and the relational proportions of these should be carefully considered. The construction is indicated in each example.

No. 52. Width of band divided into four parts. The alternate light and dark squares occupy the two centre divisions, and are determined by the 45° set-square as indicated, as is also the subdivision of the enclosing borders.

No. 52A. Simple chequer pattern, division as No. 52.

No. 53. Simple chequer pattern, division as No. 52.

No. 53A. Fret pattern, similar construction as preceding.

No. 54. Elaboration of No. 52, the alternate squares being subdivided as shown; division of total width of band into five parts.

No. 55. Development of No. 54, division of total width of band into six parts.

No. 56. Chequer pattern, division of total width of band into five parts, the enclosing borders being each one part; procedure similar to No. 52A.

No. 57. Development on same construction.

No. 58. Counter-change pattern, construction as No. 57.

No. 59. Development on same construction.

No. 60. Fret pattern on same construction with elaboration of treatment.

No. 61. Further development of No. 60.

No. 62. Fret pattern, similar construction.

No. 63. Division of total width of band into nine parts, each of the enclosing borders being one part. Alternative treatments are shown.

*No. 64. The unit of this design is the "Fylfot," a Scandinavian symbol for Thor's hammer; it is also a Buddhist symbol known as the "Swastika." In the illustration it is shown repeated in the same attitude, and repeated reciprocally. Division of total width of band into nine parts, enclosing borders each one part.

No. 65. Fret pattern, Greek, also occurs in Louis XVI, detail; division of total width of band into nine parts, enclosing borders each one part; variations are shown.

No. 66. Developments of No. 65, similar division of band.

No. 67. Fret pattern, Chinese, division of band into nine parts.

No. 68. Fret pattern, Greek, division of band into nine parts.

No. 69. Fret pattern, Greek, division of band into eleven parts.

No. 70. Fret pattern, Greek, division of band into thirteen parts.

No. 71. Fret pattern, Greek, division of band into thirteen parts.

No. 72. Fret pattern, Greek, division of band into thirteen parts.

No. 73. Fret pattern, Greek, division of band into thirteen parts.

No. 74. Fret pattern, Greek, division of band into fifteen parts.

No. 75. Fret pattern, Japanese, division of band into fourteen parts.

No. 76. Fret pattern, Pompeian, division of band into nineteen parts.

No. 77. Fret pattern, division of band into twelve parts.

No. 78. Fret pattern, Chinese, detail occupation five-sevenths of total width of band, subdivided into eleven parts.

No. 79. Fret pattern, detail occupation five-sevenths of total width of band, subdivided into nine parts.

No. 80. Fret pattern, division of band into nine parts.

No. 81. Fret pattern, division of band into nine parts.

No. 82. Fret pattern, division of band into nine parts.

*[Though this symbol has acquired hateful associations in the twentieth century, it has been retained here for historical reasons.—THE PUBLISHER, 1993]

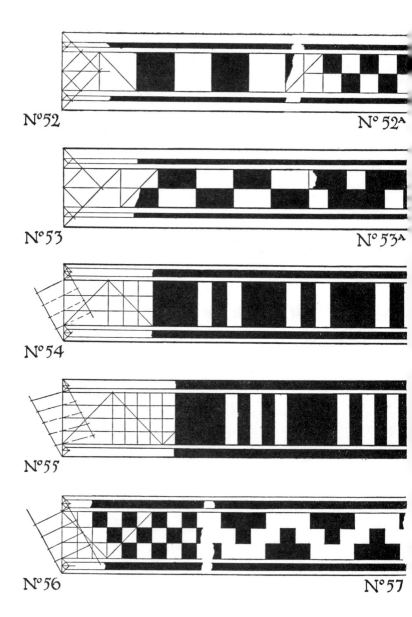

N°52 N° 52ᴬ

N°53 N° 53ᴬ

N°54

N°55

N°56 N°57

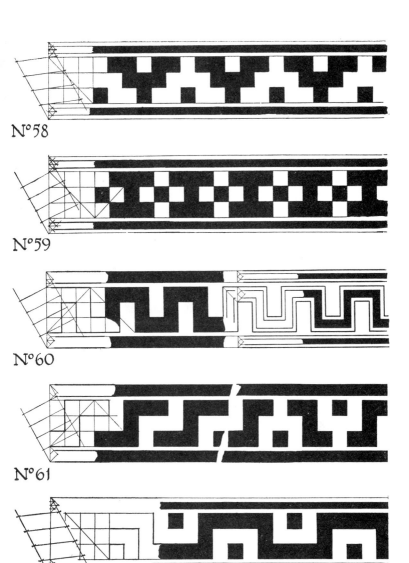

N°58

N°59

N°60

N°61

N°62

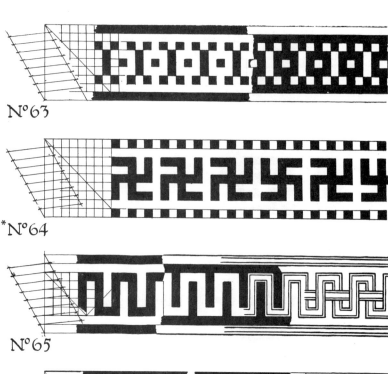

N° 63

*N° 64

N° 65

N° 66

N° 67

*See note on page 51.

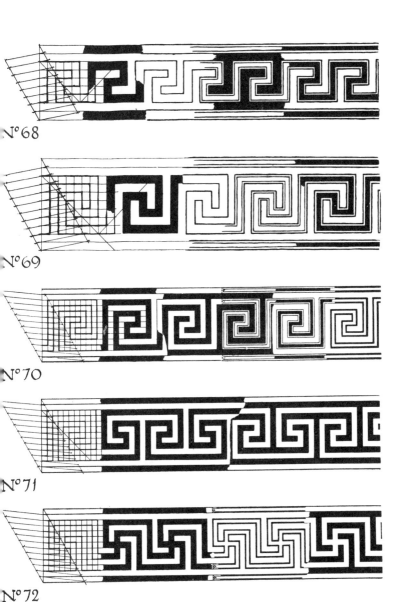

N° 68

N° 69

N° 70

N° 71

N° 72

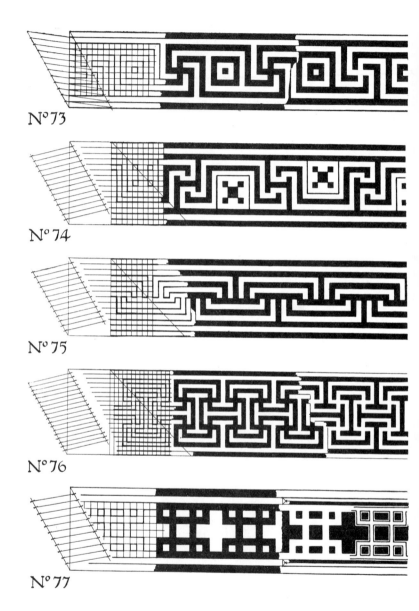

Nº 73

Nº 74

Nº 75

Nº 76

Nº 77

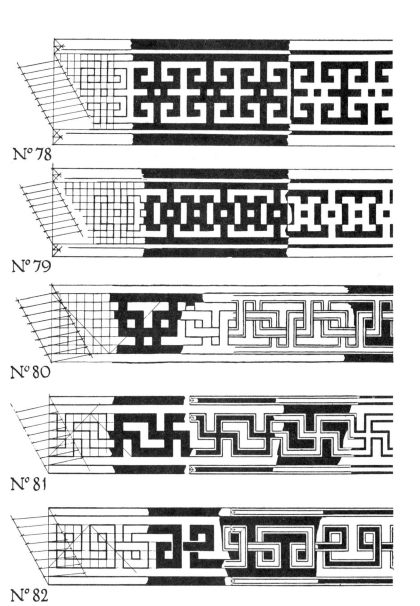

N° 78

N° 79

N° 80

N° 81

N° 82

No. 83. Fret pattern, division of band into eleven parts.

No. 84. Fret pattern, division of band into eleven parts.

No. 85. Fret pattern, Chinese, division of total width of band into twenty parts, of which the detail occupies sixteen; enclosing borders each one and a half parts.

No. 86. Fret pattern, Chinese, division of total width of band into twenty-one parts, of which the detail occupies seventeen; enclosing borders each one and a half parts.

No. 87. Border pattern, Pompeian, band divided into six parts, of which the detail occupies four.

No. 88. Chequer pattern, detail occupies four-sixths total width of band.

No. 88A. Counter-change border, detail occupies four-sixths total width of band.

No. 89. Counter-change border, detail occupies four-sixths total width of band.

No. 89A. Variant of No. 89, detail occupies four-sixths total width of band.

No. 90. Counter-change border, detail occupation five-ninths total width of band.

No. 91. Counter-change border, detail occupation four-sixths total width of band, subdivided into three parts as indicated.

No. 92. Counter-change border, division as No. 91.

No. 93. Border pattern, detail occupation four-sixths total width of band, subdivided into three parts.

No. 94. Border pattern, Persian, band divided into six parts.

No. 95. Border pattern, Arabian, band divided into nine parts.

No. 96. Border pattern, with variations, width of band divided into six parts.

No. 97. Border pattern, with variations, width of band divided into six parts.

No. 98. Border pattern, with variations, width of band divided into six parts.

No. 99. Border pattern, with variations, width of band divided into six parts.

No. 100. Border pattern, with variations, width of band divided into six parts.

No. 101. Interlacing border, with variations, width of band divided into seven parts. On these divisions are drawn the lines at 45°, which are the basis of the detail.

No. 102. Link border, with variations, width of band divided into seven parts. The engagement and width of link is determined by setting off one part from the angle of square.

No. 103. Zigzag pattern. Borders each one-sixth total width of band.

No. 104. Interlacing zigzags. Borders each one-sixth total width of band.

No. 105. Development of No. 104. Borders each one-sixth total width of band. The remaining space is subdivided into five parts.

No. 106. Interlacing pattern. Borders each one-eighth total width of band. The further division in this instance should be on a line at an angle of 45°, which should be divided into eleven parts.

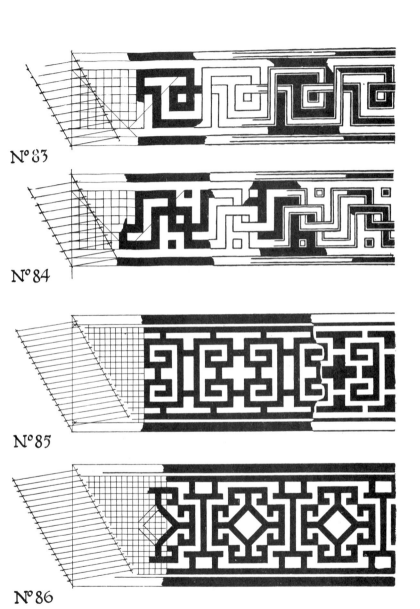

Nº 83

Nº 84

Nº 85

Nº 86

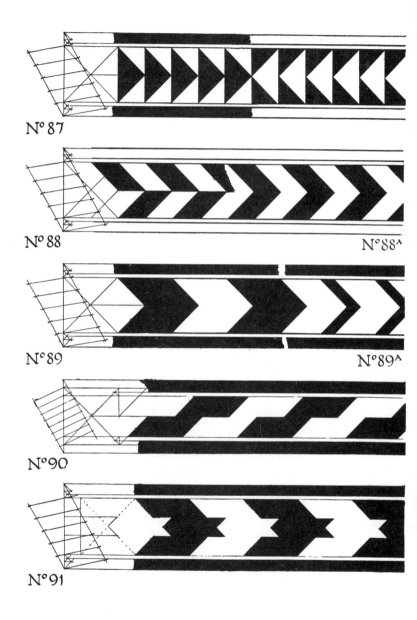

N° 87

N° 88 N°88ᴬ

N°89 N°89ᴬ

N°90

N°91

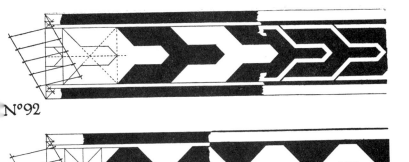

N° 92

N° 93

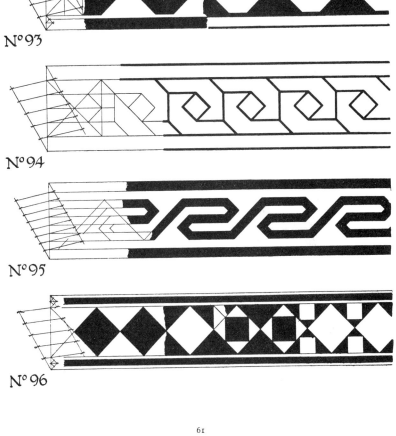

N° 94

N° 95

N° 96

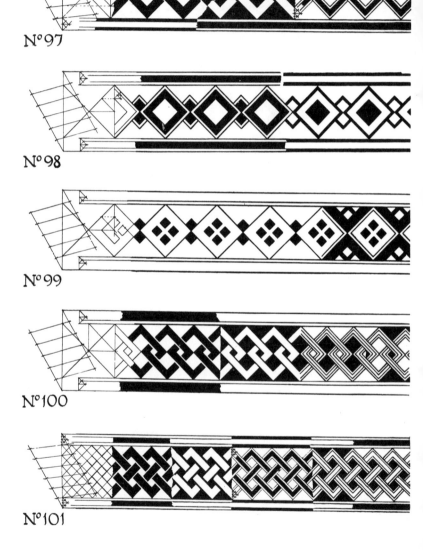

N° 97

N° 98

N° 99

N° 100

N° 101

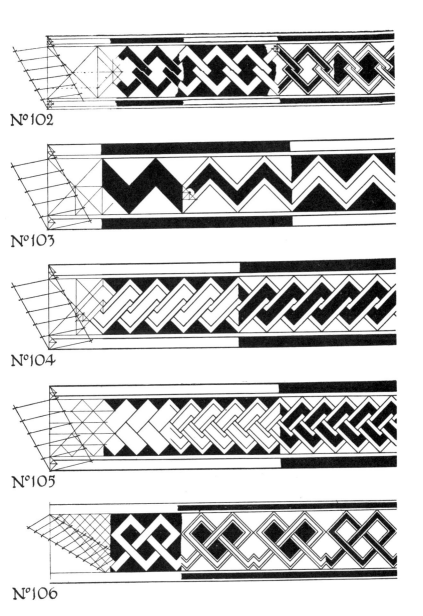

Nº102

Nº103

Nº104

Nº105

Nº106

No. 107. Interlacing pattern. Borders each one-eighth total width of band. The lines on which detail is drawn can be obtained by dividing the angle of 45° into thirteen parts.

No. 108. Interlacing pattern. Borders each one-eighth total width of band. The constructional lines of detail are obtained by division of angle of 45° into sixteen parts.

No. 109. Interlacing pattern. Division of total width of band into seven parts, five of which are required for the interlacing bands. The horizontal dimension of each unit is determined by a line at 45°, which defines the outer angles.

No. 110. Elaboration of previous example. Interlacing detail occupies five parts of total width of band. The width of interlacing bands is determined by division of an angle of 45° into ten parts.

No. 111. Further elaboration of No. 109. Detail occupies six-eighths total width of band; this is subdivided into seven parts, which gives widths and intervals of interlacement.

No. 112. Interlacing pattern. Detail occupies six-eighths of total width of band; this is subdivided into seven parts.

No. 113. Interlacing pattern, Moresque. Detail occupies six-eighths total width of band; this is subdivided into seven parts, which determine the width and intervals of interlacing bands.

No. 114. Interlacing pattern, Arabian. Detail occupies six-eighths of total width of band; this is subdivided into seven parts. From these points lines drawn at 45° will be the basis of the pattern.

No. 115. Interlacing pattern, Arabian. Detail occupies six-eighths of total width of band. The division of a line at angle of 45° into fourteen parts will give the constructional lines.

No. 116. Interlacing pattern. Detail occupies six-eighths of total width of band. To obtain construction a line at angle of 45° should be divided into sixteen parts.

No. 117. Interlacing pattern. Detail occupies five-sevenths of total width of band; this is subdivided into eleven parts.

No. 118. Interlacing pattern, Moresque. Detail occupies six-eighths of total width of band; subdivision of this into eight parts will give width of interlacing detail.

No. 119. Interlacing pattern, Moresque. Detail occupies six-eighths of total width of band; this should be subdivided into eleven parts.

No. 120. Interlacing pattern, Moresque. Detail occupies six-eighths of total width of band; this should be subdivided into eleven parts.

No. 121. Interlacing pattern. Detail occupies six-eighths of total width of band; this should be subdivided on a line at angle of 45° into fourteen parts.

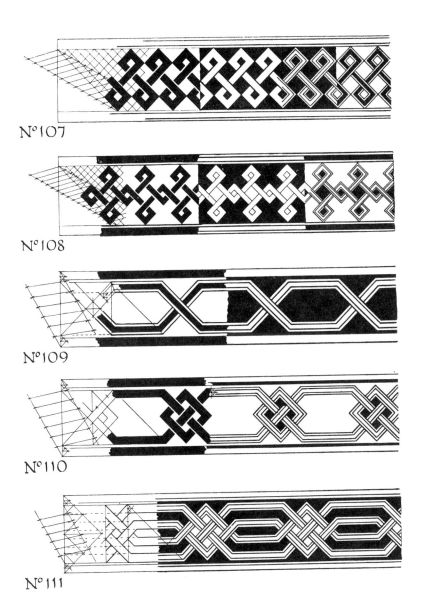

Nº107

Nº108

Nº109

Nº110

Nº111

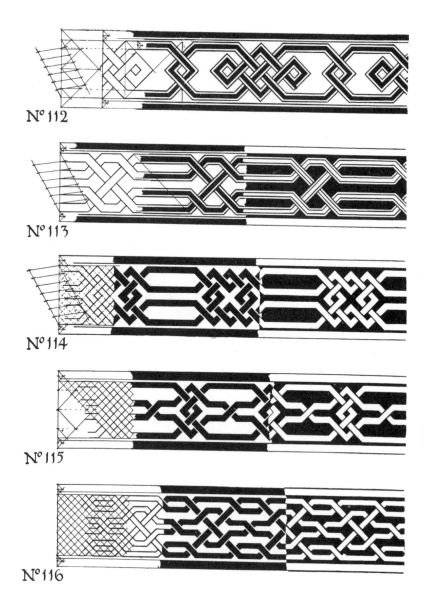

Nº 112

Nº 113

Nº 114

Nº 115

Nº 116

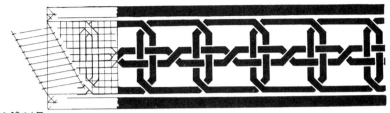

Nº 117

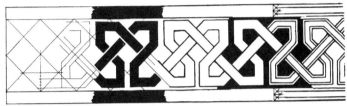

Nº 118

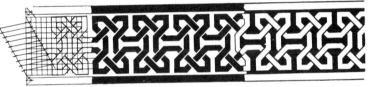

Nº 119

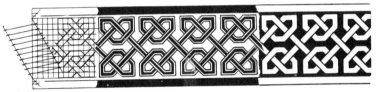

Nº 120

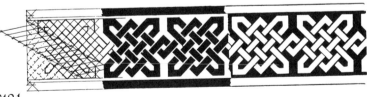

Nº 121

No. 122. Interlacing pattern. Detail occupies six-eighths of total width of band; this should be subdivided on a line at angle of 45° into sixteen parts.

No. 123. Interlacing pattern. Detail occupies five-sevenths of total width of band; this should be subdivided into eleven parts.

Note.—Many of the examples given are set out on a construction of squares, either at right angles or obliquely. As the spaces between the lines is indicative of the widths of detail, it follows that this is only so in instances where the lines of pattern are in the same direction as those of the construction; when these are at a different angle it will be necessary to set off the required widths so as to preserve uniformity in the pattern.

Patterns on Lines at Angles of 60° with Horizontal.

No. 124. Counter-change pattern with variant. Detail occupies four-sixths of total width of band.

No. 125. Border pattern. Similar dimension as No. 124. Width of detail one-fourth that of base of triangle.

No. 125A. Border pattern. Similar dimension as No. 124. Base division into six parts.

No. 126. Border pattern. Similar dimension as No. 124. Base division into eight parts.

In these two examples the intermediate triangular detail is determined by the divisions in the base of the larger details.

No. 126A. Variant. Division of base of triangle into four parts.

No. 127. Zigzag pattern with elaborated version. Similar dimensions as above.

No. 128. Zigzag pattern suggestive of folded ribbon, the width of which is determined by division of triangle into three parts. The rod running through is one-third of detail width, which is four-sixths of total width of band.

No. 129. Zigzag pattern. Detail occupies four-sixths of total width of band. The width of ribbon is one-half base of triangle.

No. 130. Interlacing zigzags. Dimensions as preceding. Width of ribbon one-fourth base of triangle.

No. 131. Interchange pattern. Detail occupies four-sixths of total width of band. The horizontal dimensions are obtained by bisection of angles of triangles as shown.

No. 132. Star pattern. Dimensions and construction similar to No. 131.

No. 133. Border pattern. Detail occupies four-sixths of total width of band. The spacing of parallel lines is due to division of base of triangle into six parts.

No. 134. Lozenge pattern, with developments. Detail occupies four-sixths of total width of band.

No. 135. Border of adjacent hexagons. Detail occupies four-sixths of total width of band; width of hexagon one-seventh its diagonal.

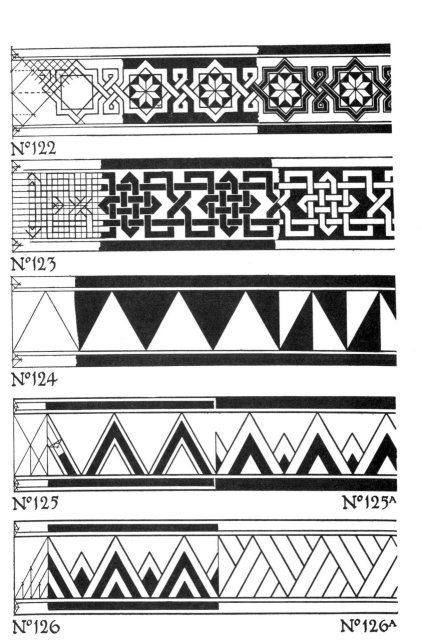

Nº122

Nº123

Nº124

Nº125 Nº125ᴬ

Nº126 Nº126ᴬ

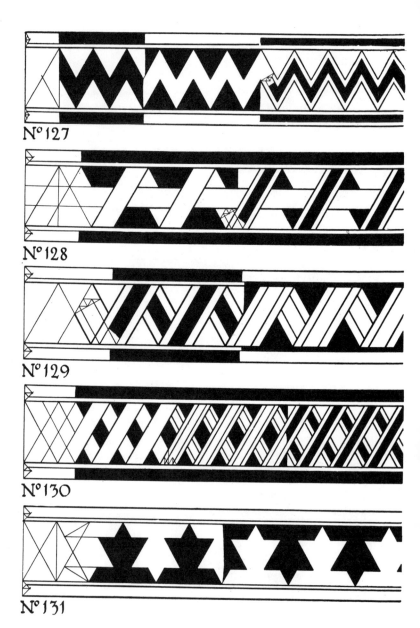

Nº 127

Nº 128

Nº 129

Nº 130

Nº 131

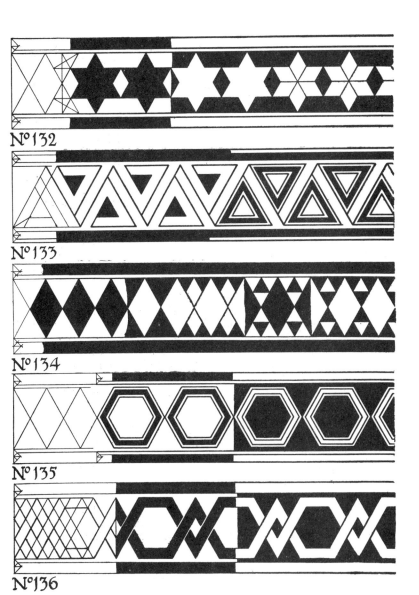

Nº 132

Nº 133

Nº 134

Nº 135

Nº 136

No. 136. Interlacing border. Detail occupies four-sixths total width of band; subdivided into three parts, from which constructional lines of patterns can be drawn.

No. 137. Pattern of linked hexagons. Detail occupation four-sixths total width of band. The method of determining width of hexagonal detail is shown.

No. 138. Pattern of intersecting hexagons. Detail occupies six-eighths of total width of band; from the other divisions construction lines are drawn.

No. 139. Interlacing pattern. Detail occupies six-eighths total width of band; this is subdivided into five parts, through which construction lines are drawn.

No. 140. Counter-change patterns. Detail occupies four-sixths of total width of band. The widths of the stripes are each one-sixth.

No. 141. Border pattern. Detail occupies four-sixths total width of band; this subdivided into six parts will give spacing of lines. The vertical lines are coincident with the angles of triangles.

No. 141A. Border pattern. Similar in dimensions and construction as No. 141.

No. 142. Link pattern. Detail occupies four-sixths total width of band. The width of link is one-sixth the length of side.

No. 143. Link pattern. Detail occupies four-sixths total width of band; this subdivided into six parts will give width of link as shown.

No. 144. Interlacing pattern. Detail occupies five-sevenths total width of band. Lines drawn through these divisions give construction as indicated.

No. 145. Border pattern, Pompeian. Detail occupies four-sixths total width of band.

No. 146. Elaboration of No. 145. Same division.

No. 147. Star pattern with development. Similar division and construction as No. 146, with the additional use of the angle of 45°.

No. 148. Maltese cross border. Detail occupies four-sixths total width of band; subdivided into six parts, one part being radius of circle in centre. The arms of the cross are at angles of 60° and 30°.

No. 149. Border pattern. Detail occupies four-sixths total width of band, and is the result of lines drawn at angles of 60° and 30°.

No. 149A. Variant of No. 149. Same dimensions and setting out.

PATTERNS FORMED OF SEGMENTS OF CIRCLES.

No. 150. Border pattern of semicircles. Detail occupies three-fifths total width of band.

No. 151. Border pattern formed by intersecting semicircles. Same division as No. 150.

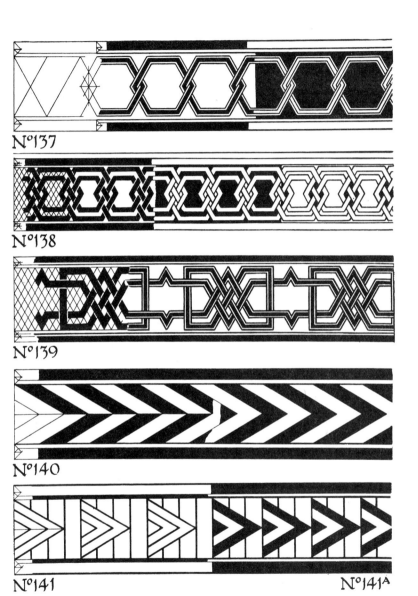

Nº137

Nº138

Nº139

Nº140

Nº141 Nº141A

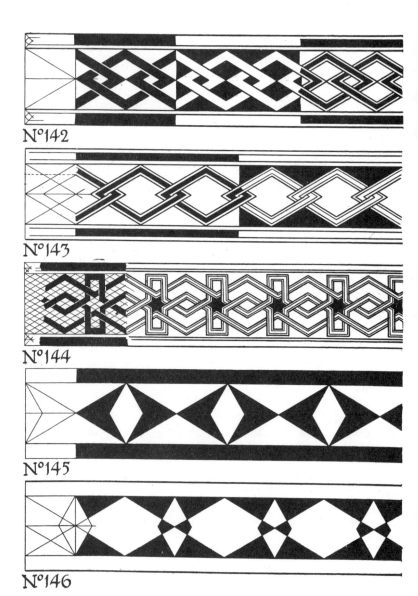

Nº142

Nº143

Nº144

Nº145

Nº146

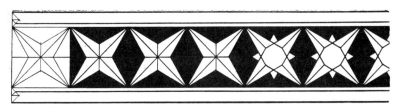

Nº147

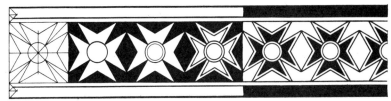

Nº148

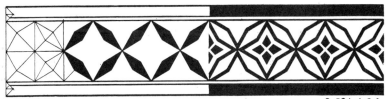

Nº149 Nº149ᴬ

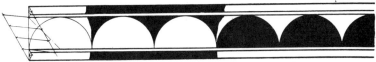

Nº150

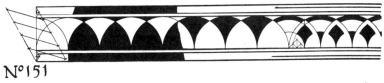

Nº151

No. 152. Border pattern, Greek. Detail occupies one-half total width of band.

No. 153. Border pattern, Greek. Detail occupies five-sevenths total width of band.

No. 154. Border pattern formed of opposed semicircles. Detail occupies five-sevenths total width of band.

No. 154A. Border pattern. Variant of No. 154. Same dimensions.

No. 155. Border pattern. Further development. Same dimensions.

No. 156. Elaboration of No. 154. Detail occupies four-sixths total width of band.

No. 157. Border of interlacing semicircular bands. Detail occupies four-sixths total width of band; one-sixth is also the width of semicircular detail.

No. 158. Elaboration of No. 157. Detail occupies five-sevenths total width of band. Width of semicircular detail also one-seventh.

No. 159. Development of No. 158. Detail occupies five-sevenths of total width of band. Width of detail also one-seventh.

No. 159A. Further development. Same dimensions and construction.

No. 160. Border pattern. Detail occupies four-sixths total width of band. The arcs of circles are struck from points in the enclosing borders which should be subdivided into three as shown. Width of curved bands one-sixth of detail space.

No. 161. Border pattern. Elaboration of No. 160. Band should be divided into five parts. The radius of the outer curves is four parts, and the centres occur on the external lines of enclosing borders.

No. 162. Border pattern. Variant of No. 160. Detail occupies three-fifths total width of band, and this is subdivided into five parts to determine width of detail. The curves are struck from centres as indicated.

No. 163. Interlacing undulate border. Detail occupies three-fifths total width of band. Width of undulate one-fifth.

No. 163A. Variant of No. 163. Same dimensions and construction.

No. 164. Elaboration of No. 163A. Detail occupies six-eighths total width of band. Width of interlacing bands one-ninth of detail space.

No. 165. Interlacing pattern. Detail occupies four-sixths total width of band. Five centres are required to strike the curved bands. The points can be found by dividing detail space into eight parts as shown.

No. 166. Interlacing pattern. Detail occupies four-sixths total width of band. Width of centre stem one-sixth. Centres of curves are indicated.

No. 167. Interlacing pattern. Detail occupies four-sixths total width of band; this should be subdivided into three parts to determine width of undulate bands.

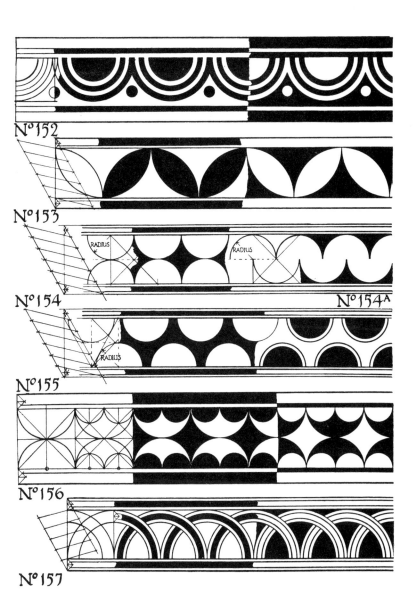

Nº152

Nº153

RADIUS RADIUS

Nº154 Nº154ᴬ

RADIUS

Nº155

Nº156

Nº157

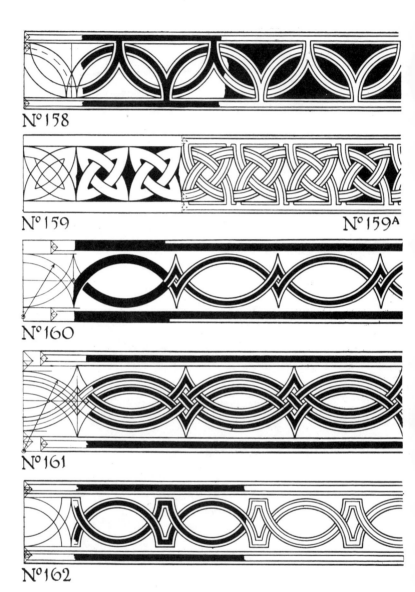

Nº158

Nº159 Nº159ᴬ

Nº160

Nº161

Nº162

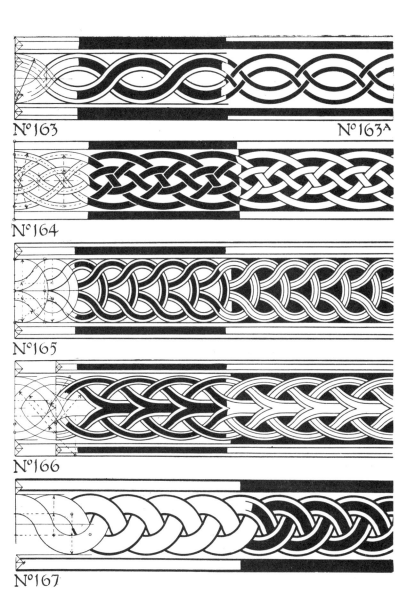

Nº163 Nº163ᴬ

Nº164

Nº165

Nº166

Nº167

No. 168. Interlacing pattern. Detail occupies four-sixths total width of band. Centres of curves are on lines, result of the same division as shown.

No. 169. Interlacing pattern. Detail occupies four-sixths total width of band. The pattern is the result of adjacent circles. A shifted centre is required for the arc expressing edge of band.

No. 170. Interlacing pattern. Detail occupies seven-ninths total width of band. Width of interlacing detail one-ninth.

No. 171. Border pattern. Greek elaboration of No. 154A. Detail occupies four-sixths total width of band.

No. 172. Border pattern with development. Detail occupies five-sevenths total width of band.

No. 173. Border pattern. Elaboration of No. 155. Detail occupies four-sixths total width of band. Centres of curves are indicated.

No. 174. Counter-change pattern with variants. Result of quadrants struck from a basis of squares. Detail occupies four-sixths total width of band.

No. 175. Border pattern, Greek with variant. Detail occupies four-sixths of total width of band. Result of quadrants struck form a square basis.

No. 176. Border pattern. Development of No. 175. Similar dimensions and construction.

No. 177. Border pattern. Further variant of No. 175.

No. 178. Border pattern composed of segments of circles: centres determined by squares. Detail occupies three-fifths total width of band.

No. 179. Border pattern composed of segments of circles. Detail occupies four-sixths total width of band. To obtain the radius of semicircle the detail space should be subdivided into six parts. Centres are indicated.

No. 180. Border pattern, Indian. Detail occupies four-sixths total width of band. Centres of curves are indicated.

No. 181. Border pattern, Gothic. Detail occupies six-eighths total width of band. The centres of the larger radial curves are determined by division of sides of the square into four parts. The centres of the smaller curves can also be obtained by division of these sides into three parts. The radius of the centre circle is defined by these curves.

No. 182. Lotus border, Egyptian. Detail occupies four-sixths total width of band. The arcs of circles are struck as shown, that for the base of flower having a radius of one-sixth. The curves of the sides should then be struck, the centres being on the external lines of enclosing borders. The remainder is free-hand.

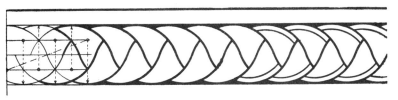

Nº168

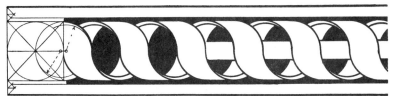

Nº169

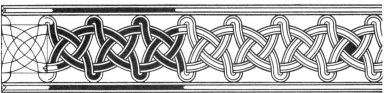

Nº170

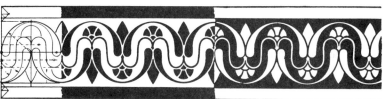

Nº171

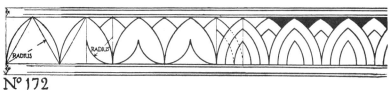

Nº172

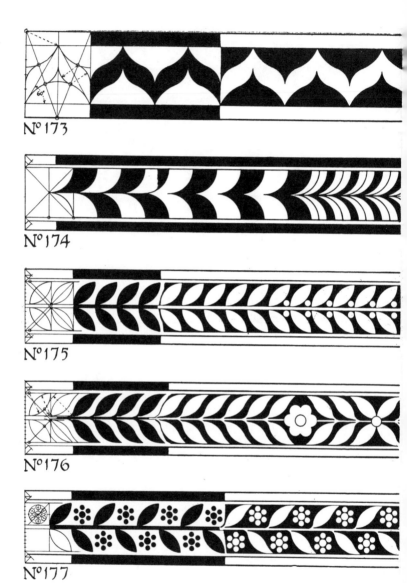

Nº 173

Nº 174

Nº 175

Nº 176

Nº 177

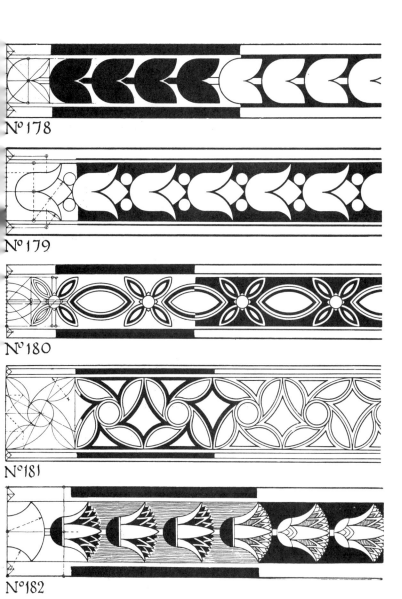

Nº 178

Nº 179

Nº 180

Nº 181

Nº 182

No. 183. Lotus border, Egyptian. Detail occupies four-sixths total width of band. The setting out of detail is by intersecting circles as indicated.

No. 184. Disk border, result of adjacent circles. Detail occupies four-sixths of total width of band.

No. 185. Border pattern, result of intersecting circles.

No. 185A. Border pattern, result of intersecting circles.

No. 186. Border pattern, result of intersecting circles.

No. 187. Pattern of interlacing rings. Detail occupies four-sixths total width of band, subdivided into six parts to determine width of ring.

No. 188. Interlaced pattern of large and small circles. Detail occupies four-sixths of total width of band, subdivided into eight parts to determine width of circles. The radius of smaller circle is one-half that of the larger.

No. 189. Elaboration of No. 188, Byzantine. Dimensions the same as No. 188.

No. 190. Guilloche border, Assyrian. Detail occupies four-sixths total width of band. This pattern in working is much the same as No. 189, except that the width of borders to circular forms is one-twelfth of detail space.

No. 191. Guilloche border, Greek. Detail occupies four-sixths total width of band. This pattern is a double version of No. 190 reciprocally arranged.

No. 192. Guilloche border, Greek. Similar to preceding example, except that the circles are struck from lines at 60° with horizontal.

No. 193. Guilloche border, Greek. Further elaboration in having three tiers of circles. Construction as No. 192.

No. 194. Interlacing pattern, Byzantine. Elaboration of No. 187. Detail occupies six-eighths total width of band. The radius of small circle is one-third that of the larger. Width of circular bands one-sixteenth of total.

No. 195. Interlacing pattern, Byzantine. Similar to preceding example but continuous. Detail occupies six-eighths total width of band. Width of circular detail one-ninth of detail space.

No. 196. Interlacing pattern. Elaboration of No. 159A. Division of total width of band into eleven parts, the borders and interlacing bands being each one part wide.

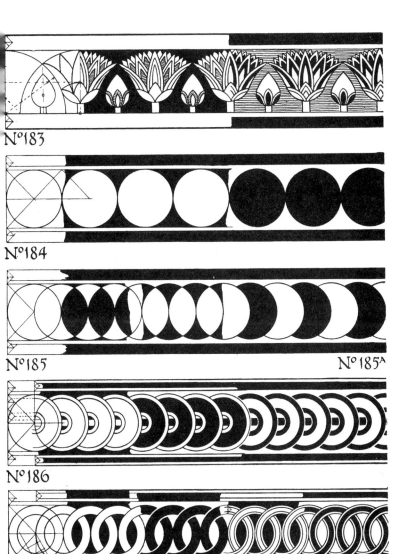

N°183

N°184

N°185 N°185ᴬ

N°186

N°187

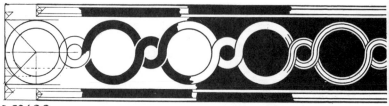

N°188

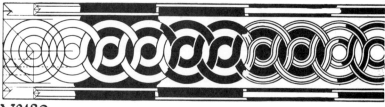

N°189

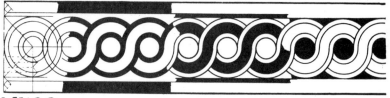

N°190

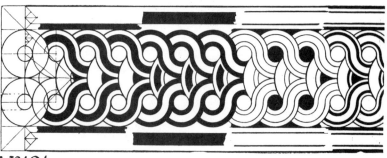

N°191

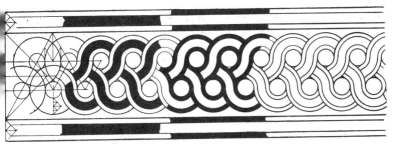

N°192

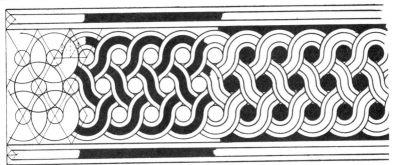

N°193

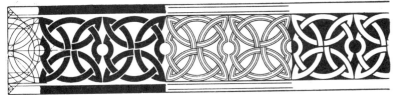

N°194

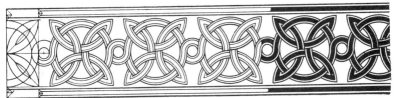

N°195

No. 197. Border pattern. Elaboration of No. 184. Detail occupies five-sevenths total width of band. The centres of curves are the centre and external angles of intersecting squares.

No. 198. Border pattern. Detail occupies four-sixths total width of band.

No. 199. Border pattern. Detail occupies four-sixths total width of band.

Various treatments are shown of these last three patterns, but the construction in each instance will be evident.

No. 200. Border pattern formed of circles and semicircles. Detail occupies five-sevenths total width of band. Centres of curves are on squares.

No. 201. Border pattern. Variation of No. 200 arranged as a counter-change. Dimensions and method of working the same.

No. 202. Border pattern. Elaboration of No. 201. Detail occupies five-sevenths total width of band. Width of curved bands one-fourteenth of total width.

No. 203. Border pattern. Indian variant of No. 201. Detail occupies four-sixths total width of band.

No. 204. Border pattern. Counter-change. Detail occupies four-sixths total width of band.

No. 204A. Border pattern. Variant of No. 204.

No. 205. Rosette border. Detail occupies four-sixths total width of band; radius of small circle one-twelfth the whole, and space between large circles also one-twelfth.

No. 206. Rosette border. Dimensions and construction as No. 205. The rosettes in both are divided into twelve petals.

No. 207. Evolute border. Detail occupies four-sixths total width of band. The distance between circles is determined by the connecting-stem which is struck from the point indicated. The petals of rosettes and axiliary flowers are necessarily freehand.

Combinations of Curved and Straight Lines.

No. 208. Guilloche pattern. Detail occupies four-sixths total width of band.

No. 209. Guilloche pattern. Detail occupies four-sixths total width of band.

No. 210. Guilloche pattern. Detail occupies six-eighths total width of band.

These three patterns are similar in construction, the centres of circles in each case being struck from the intersections of lines drawn at an angle of 45°.

In Nos. 208 and 210 the outer circles touch, but in No. 209 the outer circles join to the small inner circles. In the first two examples the outer circles should be first drawn; the diameter of the inner circle can then be determined by tangents at 45°.

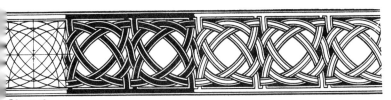

Nº196

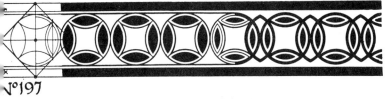

Nº197

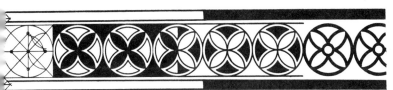

Nº198

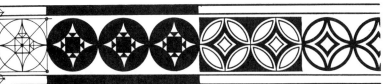

Nº199

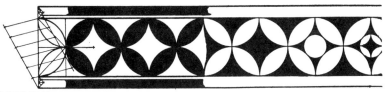

Nº200

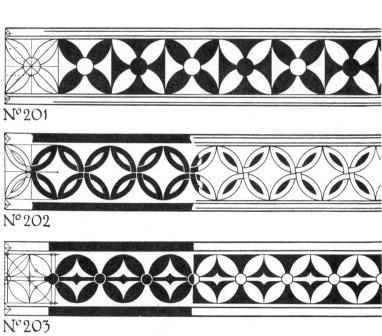

N.º 201

N.º 202

N.º 203

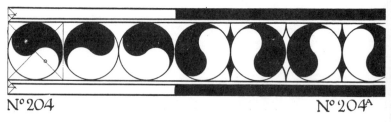

N.º 204 N.º 204ᴬ

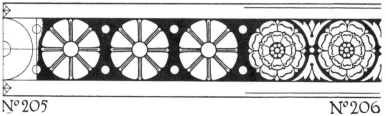

N.º 205 N.º 206

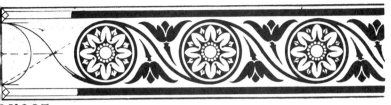

Nº 207

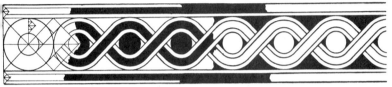

Nº 208

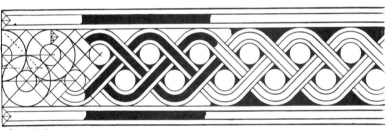

Nº 209

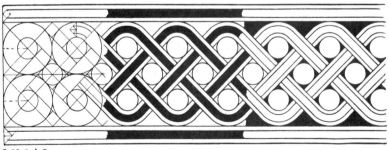

Nº 210

No. 211. Interlacing pattern. Detail occupies four-sixths total width of band. The pattern is formed by adjacent circles struck from the intersection of lines forming squares. The width of interlacing detail is determined by drawing a tangent at 45° to the larger circle, which gives the radius for the smaller circle.

No. 212. Variations of No. 211.

No. 213. Variations of No. 211. The centres in this version are the angles, the intersections of lines at 60° with horizontal.

No. 214. Interlacing border. Detail occupies five-sevenths of total width of band. The construction consists of two rows of adjacent circles, the radius of which is one-sixth total width. The breadth of these is defined by tangents at 45°; this also gives radius for inner circles.

No. 215. Interlacing border based on the "Wake Knot." Detail occupies four-sixths total width of band. The curve of the "knot" is struck from three centres. Subdivision of the detail space into eight parts will give the centre of the larger arc; from this centre lines should be drawn at angles of 45° intersecting the large curve; this will enable the centres of the semicircles to be found. The space between the units is also one-eighth of the detail space. A centre line should be drawn intersecting a line at 45° from A. From this intersection a chord should be made and bisected to find the centre for striking the required curve of continuing band; this also decides the width of interlacing band.

No. 216. Elaboration of No. 215. Detail occupies six-eighths of total width of band; this should be subdivided into eleven parts, and at points one part distant from inner lines of borders will be the line from which the larger curves can be struck. The semicircles can be arrived at as in No. 215 as shown.

No. 217. Interlacing pattern, Celtic. Detail occupies six-eighths total width of band. The small square at angle of 45° should first be drawn, its vertical dimension being one-half of detail space. This will form the outer lines of crossing bands. The bisection of a line drawn from A to horizontal angle will give the centres of circles. Division of side of square into three parts will give width of interlacing bands; the space between the units is one-half the width of these. As before, a centre line should be drawn, and the bisection of a chord as shown will define the centre of small connecting curve.

No. 218. Interlacing pattern. Border and detail each one-twelfth of total width of band. Construction and centres of curves as indicated.

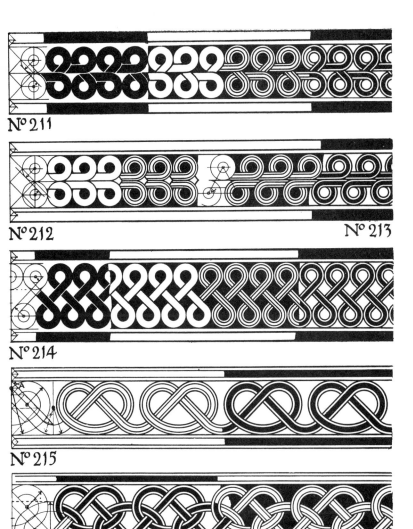

Nº 211

Nº 212

Nº 213

Nº 214

Nº 215

Nº 216

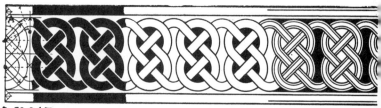

Nº 217

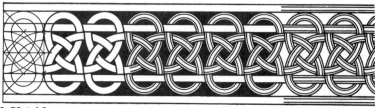

Nº 218

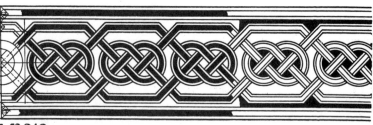

Nº 219

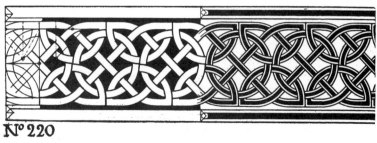

Nº 220

No. 219. Interlacing pattern, Celtic. Detail occupies five-sevenths of total width of band; this is subdivided into nine parts, one of which is the width of interlacing bands. The circular knot should be first drawn. The interval between the units is one-eighteenth.

No. 220. Interlacing pattern, Celtic. Borders each one-tenth total width of band. The same division will give the inner horizontal lines of detail on which are the centres of semicircles. Width of interlacing bands one-twelfth.

No. 221. Interlacing pattern. Detail occupies four-sixths total width of band. The interlacement is set out on oblique lines at 45° which define the width. These lines are arrived at by a vertical division into six parts.

No. 222. Interlacing pattern. Detail occupies six-eighths of total width of band. The interlacement is set out on oblique lines at angles of 45° which determine the width. These lines are arrived at by a vertical division into eleven parts.

No. 223. Interlacing pattern, Celtic. Detail occupies six-eighths of total width of band; this should be subdivided into twelve parts, one of which is the width of interlacing bands. Centres of semicircles are indicated.

No. 224. Border pattern with varied treatments. Detail occupies four-sixths total width of band; this should be subdivided into thirteen parts, one of which is width of detail. The centre of semicircles is five of these parts from inner line of bottom border; they should be struck first and the vertical lines drawn from them.

No. 225. Border pattern with varied treatments. Detail occupies four-sixths of total width of band. The vertical units are each one-sixth centre to centre.

No. 226. Border pattern as previous example. The vertical units are three-eighteenths centre to centre.

No. 227. Border pattern with varied treatments. Enclosing borders each one-seventh total width of band. The centres of semicircles are also one-seventh from inner lines of borders. Width of detail band one-fourteenth. Radius of small circle two-thirds that of semicircle.

No. 228. Border pattern. Detail occupies five-sevenths total width of band; this is subdivided into six parts, the centres of semicircles being each one-sixth from inner lines of enclosing borders. Radius of circles two-thirds that of semicircles.

No. 229. Border pattern. Detail occupies five-sevenths total width of band; this is subdivided into six parts, one of which is radius of semicircles. Centres one-sixth apart. The diameter of the band is equal to width of band of oval.

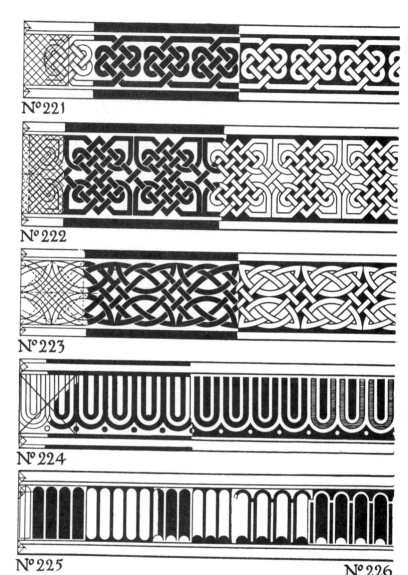

N° 221

N° 222

N° 223

N° 224

N° 225 N° 226

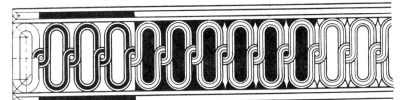

Nº 227

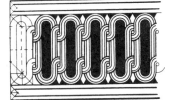

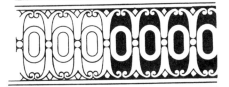

Nº 228

Nº 229

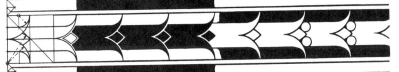

Nº 230

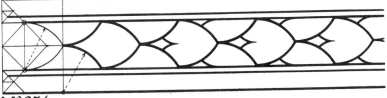

Nº 231

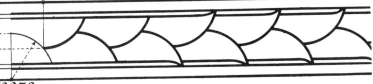

Nº 232

No. 230. Leaf border. Detail occupies three-fifths total width of band; this is subdivided into four parts. Centres are indicated.

No. 231. Leaf border. Detail occupies one-half total width of band. Centres of curves are indicated.

No. 232. Leaf border with elaboration. Detail occupies three-fifths total width of band. Centres of curves are on external lines of enclosing borders.

No. 233. Counter-change pattern. Detail occupies four-sixths total width of band; this is subdivided into six parts, which gives the spacing of vertical lines and centres of curves.

PATTERNS ON THE UNDULATE LINE.

No. 234. Counter-change pattern. Detail occupies three-fifths total width of band. Centres of curves are on central horizontal line.

No. 235. Counter-change pattern. Detail occupies three-fifths total width of band. The centres of curves are on lines drawn through this division as shown.

In the following border patterns the geometric element is in the construction, the detail though repeated being in the main free-hand.

No. 236. Leaf border from Gothic illumination. Detail occupies four-sixths of total width of band. The centre undulate is the result of semicircles struck from central horizontal line. Width of rod one-eighth of detail space.

No. 237. Leaf border. Detail occupies three-fifths total width of band. The undulate line is struck from centres as shown.

No. 238. Leaf border. Detail occupies three-fifths total width of band. The undulate line is struck from centres on external lines of the detail space.

No. 239. Floral border. Detail occupies three-fifths total width of band. The undulate line is struck from centres on these divisions as shown. Note the position of centre of circle which controls general shape of flower.

No. 240. Floral border. Detail occupies four-sixths total width of band. The undulate line is struck from centres on these divisions.

No. 241. Conventional ivy border, Greek. Detail occupies four-sixths total width of band. The undulate line is struck from centres on these divisions.

No. 242. Conventional ivy border, as No. 241.

No. 243. Conventional ivy border, Greek. Similar spacing and construction as No. 241.

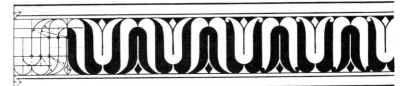

N°233

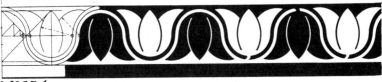

N°234

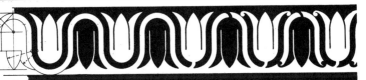

N°235

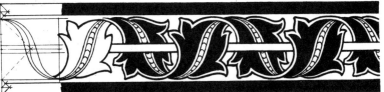

N°236

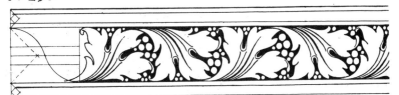

N°237

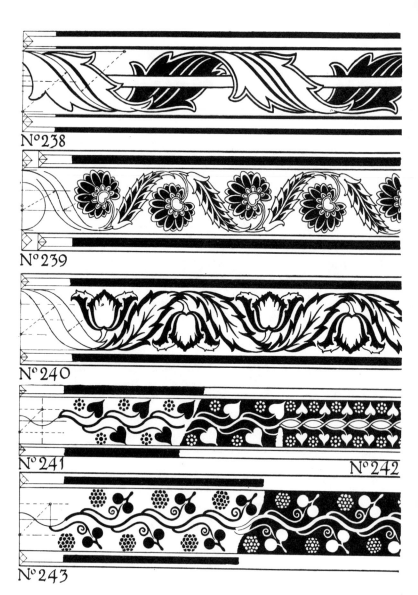

Nº238

Nº239

Nº240

Nº241

Nº242

Nº243

No. 244. Conventional vine border, Greek. Detail occupies six-eighths total width of band. The undulate line is struck from centres of these divisions as shown.

No. 245. Conventional floral border, Indian. Detail occupies four-sixths total width of band. The centres of undulate line are struck from external lines of detail space.

No. 246. Conventional floral border, Indian. Detail occupies four-sixths total width of band. The centres of undulate line are struck from external lines as shown.

No. 247. Conventional floral border, Gothic. Detail occupies four-sixths total width of band. The centres of undulate line are struck from external lines of detail space.

No. 248. Conventional floral border. Detail occupies three-fifths total width of band. The undulate line is struck from external lines of detail space. Note position of centres of circles controlling general shape of berries.

No. 249. Conventional floral border. Detail occupies four-sixths total width of band. The undulate line is struck from lines, result of subdivision into three parts as shown.

No. 250. Conventional floral border. Detail occupies four-sixths total width of band. The undulate line is struck from lines, result of subdivision into three parts.

No. 251. Conventional floral pattern. Band is divided into six parts. The undulate line is struck from centres on lines one part distant from external lines as shown.

No. 252. Conventional border, Gothic illumination. Detail occupies three-fifths total width of band. Centres of undulates are on external lines of detail space.

No. 253. Elaboration of No. 252.

No. 254. Conventional floral border. Detail occupies four-sixths total width of band. This is subdivided into three parts, and on lines drawn through these will occur the striking centres of undulate lines.

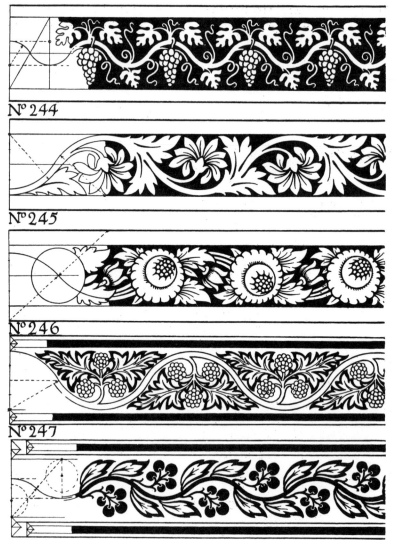

Nº 244

Nº 245

Nº 246

Nº 247

Nº 248

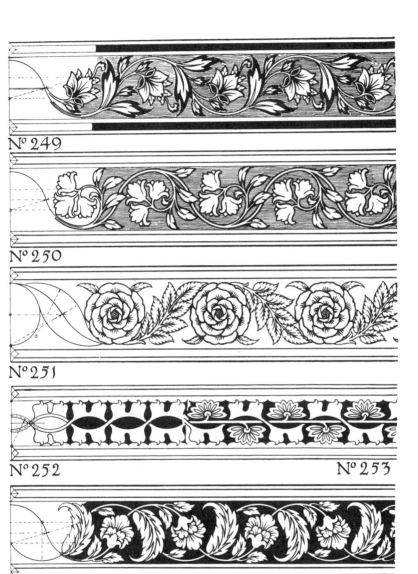

Nº 249

Nº 250

Nº 251

Nº 252

Nº 253

Nº 254

TEXTILE PATTERNS

THE essence of pattern is repetition, and in many forms of decorative work this is ensured by the process of production, as for instance in the case of wall-paper and textile designs. These, whether printed or woven, consist of a mechanically repeated unit which is relatively only a small portion of the area.

If the artist were not trammelled by any such conditions and his work could be free in treatment and variety, it would not necessarily be pattern, as some degree of æsthetic restraint would be essential to bring it within this category. For work to be decorative some note of iteration in colour, mass, or rhythm must be evident, regardless of the subject or elements employed.

The object of pattern is to give interest to surface. In plaiting and weaving, identical in principle, the crossing of the strands or threads alone results in a simple form of pattern. This is enhanced by the employment of threads of different colours. This possibility of adding to the interest of the surface apparently appealed to the primitive mind, for it is seen in textiles of a very early date. The simplest form of such pattern is arrived at by crossing white threads with black, and these appear when woven as an alternation of black and white dots. The effect can be made much more interesting by a preponderance of one of these threads. The spacing of lines will alone give an interest to surface. This can be simply demonstrated by drawing a number of parallel lines uniformly spaced and of equal thickness, as in illustration No. 255. This constitutes pattern, but is somewhat monotonous in effect. The interest is enhanced by the omission of every third line, as in No. 256. Nos. 257, 258, and 259 are examples of development in grouping and treatment. In every instance the original

N°255

N°256

N°257

N°258 N°259

N°260

N°261

N°262

N°263

spacing is the same. The varying effects are due to omission and emphasis of line.

These patterns can be elaborated by similarly spaced lines crossing at right angles. The monotony of closely spaced lines is avoided in No. 260; the widely spaced lines form a lattice. Nos. 261 and 262 are the result of crossing Nos. 259 and 257. No. 263 is a further elaboration of similar spacing.

Lines in one direction only obviously form stripes in which the lines or bands constitute the pattern. When intersected by similar lines and bands the result is the trellis or lattice, and the plaid. In both cases the lines can be used as the geometric basis for floral or other ornamentation.

IMPORTANCE OF STRAIGHT LINE.

The straight line is seldom appreciated as a factor of effect. In early essays in design, it is often regarded as mechanical, and it plays a very second fiddle to curves, which perhaps naturally appeal to the neophyte as more ornamental.

On reflection the importance of the straight line in structural work will be realized. It preponderates in Architecture, where a successful result depends on the proportionate heights and widths of the various features. A building can be a fine design with no other decoration than that which arises directly from the structure; any other ornament may be not merely unnecessary but detrimental to the effect.

The foregoing diagrams may suggest that straight lines can be used effectively. Nos. 264 and 265 are patterns based on the vertical line; the same unit is employed, but in the latter alternate units are dropped giving a more elaborate effect.

The patterns which follow are more complicated, but in every case the geometric construction is shown, and there should be no difficulty in drawing them. It is not of course contended that the examples are exhaustive; the possibilities are endless, and further examples must be left to the initiative of the student. The majority are the direct result of geometrical instruments, but the detail of some must be drawn free-hand; as, for example, No. 277, which is an elaborated version of the simple counter-

change No. 276. One unit of such detail should be carefully drawn and repeated by tracing and transferring.

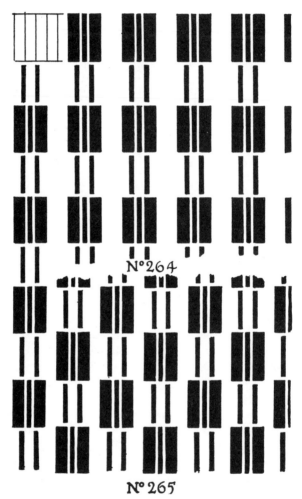

N° 264

N° 265

THE UNIT.

When mechanical production is involved, any pattern that is to be repeated in both directions indefinitely is usually designed as a unit. The geometric basis of the unit may be the result of

lines intersecting horizontally and vertically, or diagonally, dividing the area into equal-sized parts. The unit of the former would be a square or rectangle, and the latter a lozenge, or as it is more generally called the Diamond. This may be relatively only a small part of the area. The size of the unit in designs for patterns, either printed or woven, is determined by the width of material involved. Wall-papers, for instance, are produced in widths of 21 in., and that of the unit may be this or any division of the same. The height of the unit is governed by similar dimensions up to 24 in. Cretonnes are generally 30 in., and tapestry 54 in. in width: the unit in either is obtained by subdivision of these dimensions.

Patterns designed on the square or rectangle are usually side-to side repeats; they may be symmetrical on a central axis or balanced. It is not desirable to design the detail to fit to the boundary lines of the unit, as a division of space forming a trellis between the units would be the inevitable result. The detail should be taken over the lines in places, more particularly if the pattern is closely spaced, to disguise the joins. To secure this unity of effect it is as well to consider how the pattern will join, not only from side to side, but from top to bottom, at an early stage of the design.

It will be apparent that to secure the joining of the units two boundaries only have to be considered.

Thus A and B are the enclosing lines at top and left hand, but they also fulfil the same function for the adjacent unit, therefore any detail that is taken outside the line B on the left will invade the rectangle on the opposite side; the detail at A can be transferred to the lower line, and that at B to the enclosing l'ne on the right. When this is done the joins are effected and the centre is left free for the remainder of the detail. From the first there should be some conception of the whole design, so that the details at the joins should be a logical part of the general scheme.

Similar procedure is involved when the diamond plan is adopted, whether the design be symmetrical or balanced.

The diamond plan results in a pattern in which the unit is dropped vertically; this must not be confused with what is known technically as a "Drop Pattern," as a design on the diamond is not in every case a drop in this sense,

The drop pattern is really due to limitation in width of material, particularly wall-papers, which are produced in 21-in. widths and joined in the hanging. The drop is an economical device to avoid waste, which is often inevitable, as the pattern has to be matched, that is, each successive strip must fit exactly, so that the joins are imperceptible. Obviously the greater the height of the unit the more waste there may be in hanging.

The diagrams on opposite page show that the diamond is not necessarily a drop, but may be under some circumstances.

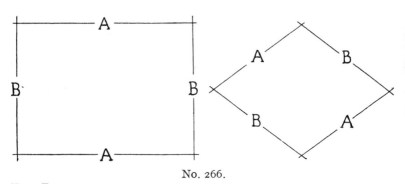

No. 266.

THE DROP.

The Drop Pattern is often given as an examination exercise. The usual plan is a half drop. In dealing with this no attempt should be made to define the diamond plan, though as a matter of fact, the pattern may eventually have the same effect as one planned on a diamond. The simple procedure is to adopt an oblique direction of line crossing the boundary between the two units, and repeat this where it should occur on the other boundaries. The pattern can then be composed in any way that is thought desirable, but as the original line or stem will mark a decided oblique direction, the dominant detail should be opposed to this to restore the balance. Example No. 353.

The geometrical plan serves the purpose of defining the unit, and evidence of it may be lost in the finished pattern. It may, however, be utilized as a feature in the design in the form of bands either plain or decorated enclosing other detail, as in so-called "Diaper" patterns.

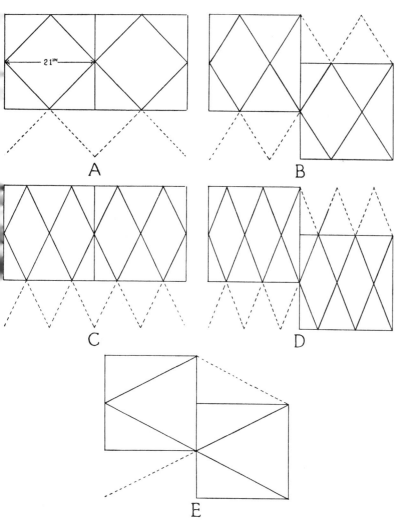

No. 267. A and C. Side to side repeats.
B, D, and E. Drop patterns.
Solid lines show how pattern has to be matched in hanging.

Patterns Nos. 354, 355 are simple examples on the diamond plan. Both designs show conventional treatments of the rose. The position and general shapes of the flowers are defined by circles, as are also to some extent the sprays of leaves.

In No. 354 the detail slightly invades the adjacent units, and in 355 closely conforms to the boundary lines. In both the undesirable trellis effect is obviated.

PATTERNS BASED ON SQUARES.

No. 268. Pattern formed of crossing bands with variant showing further interest imparted by chequers.

No. 269. Pattern formed of interlacing bands with variations in effect.

No. 270. Chequer pattern.

No. 271. Pattern based on chequers separated by interlacing bands.

No. 272. Chequer pattern. Savage art. Sandwich Islands.

Nos. 273 and 274. Patterns based on chequers.

No. 275. Chequer pattern; constructional lines at angle of 45°.

No. 276. Interchange pattern; constructional lines at angle of 45°.

No. 277. Conventional floral pattern, development of No. 276.

No. 278. Pattern based on chequers.

No. 279. Pattern based on chequers.

No. 280. Pattern based on chequers.

No. 281. Pattern based on chequers. Japanese.

No. 282. Interlacing fret pattern. Japanese.

No. 283. Pattern based on chequers with variant in effect.

No. 284. Lattice pattern.

No. 285. Pattern formed of squares of alternate detail.

No. 286. Interlacing pattern.

No. 287. Floral pattern based on chequers.

No. 288. Floral pattern based on chequers.

No. 289. Floral pattern based on chequers.

No. 290. Floral pattern based on chequers.

　　　　The preceding, with the exception of Nos. 275, 276, 277, 285, are the result of vertical and horizontal lines; the constructional lines of the following are oblique:—

No. 291. Pattern formed of squares at angle of 45°.

No. 292. Interlacing pattern of bands at angle of 45°.

No. 293. Pattern of bands crossing at angle of 45° enclosing conventional detail.

No. 294. Pattern of bands crossing at angle of 45° enclosing conventional detail.

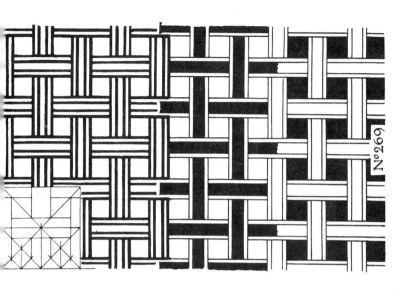

N°269

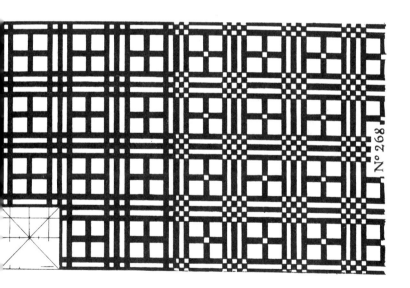

N°268

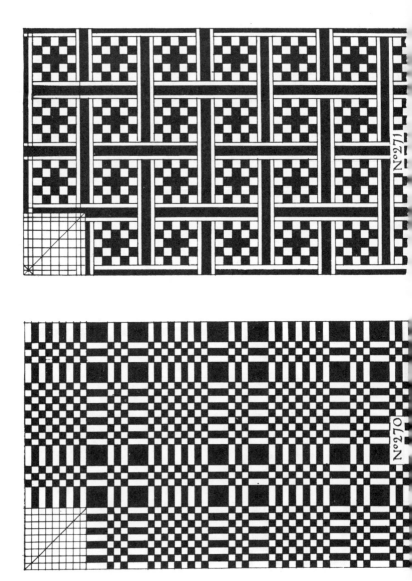

Nº271

Nº270

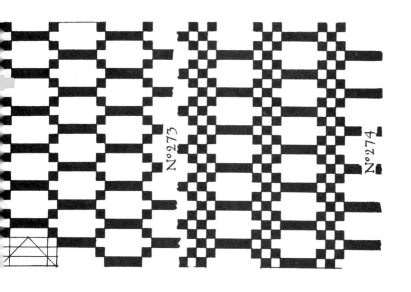

N° 273

N° 274

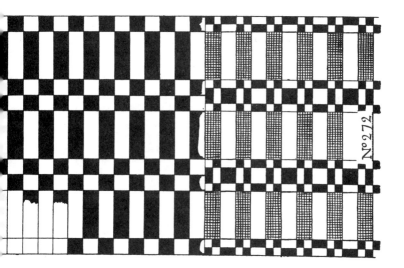

N° 272

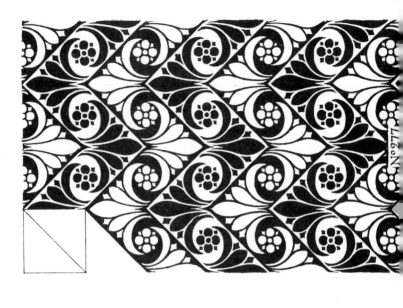

N° 277

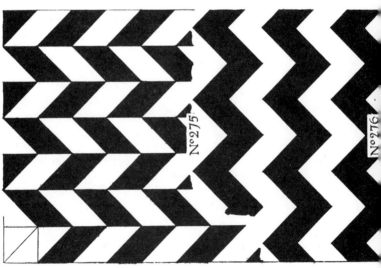

N° 275

N° 276

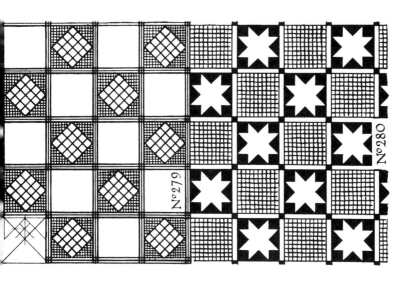

N°279

N°280

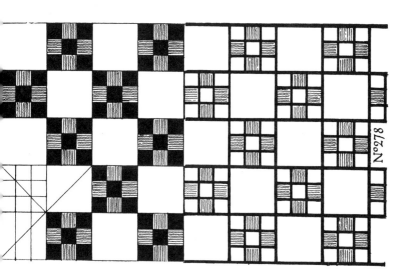

N°278

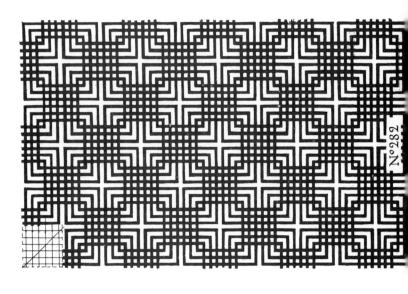

N° 282

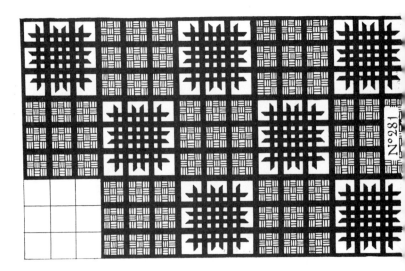

N° 281

118

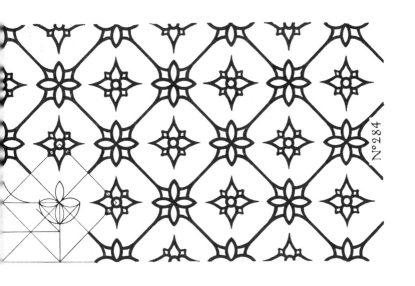

Nº 284

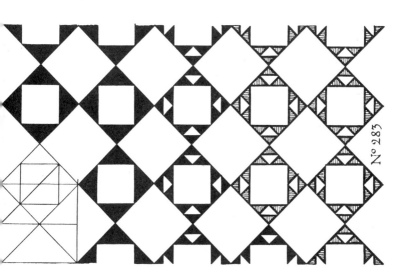

Nº 283

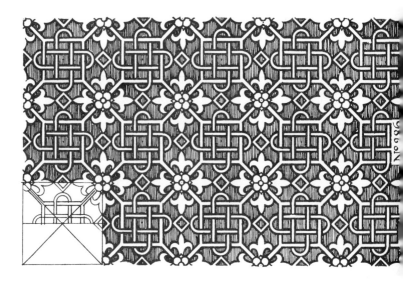

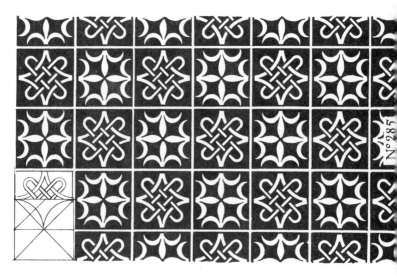

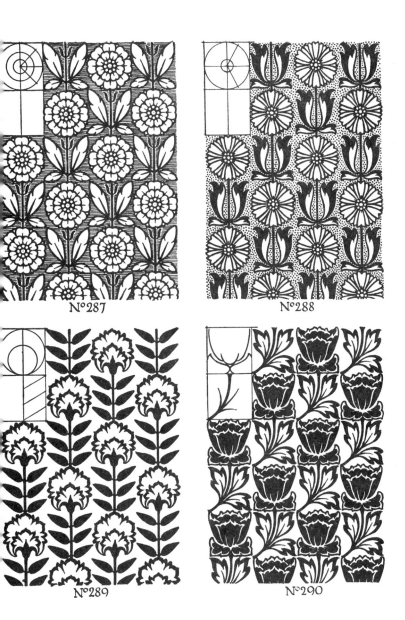

Nº287

Nº288

Nº289

Nº290

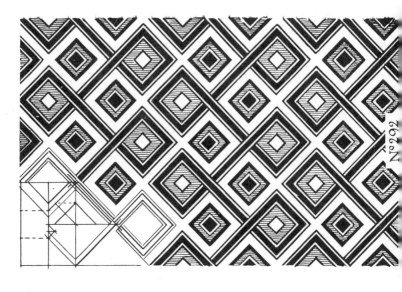

N° 292

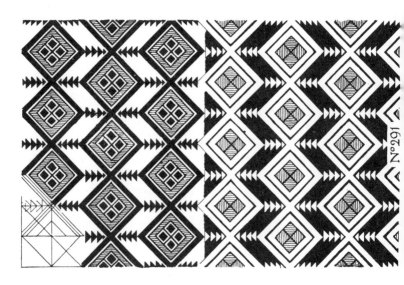

N° 291

122

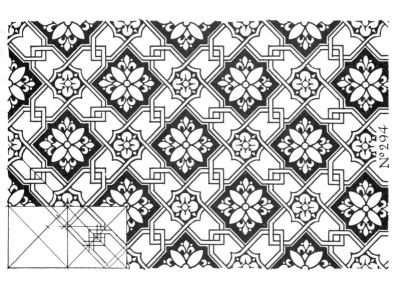

N° 294

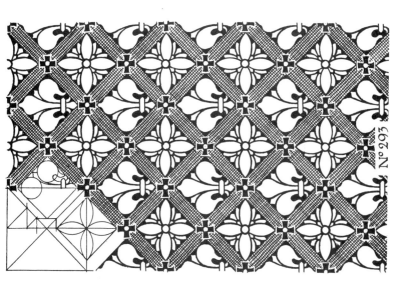

N° 293

No. 295. Elaborated lattice pattern: constructional lines 30° with vertical.
No. 296. Elaborated lattice pattern: constructional lines 30° with vertical.
No. 297. Lattice pattern with variations of effect: lines 30° with vertical.
No. 298. Interlacing pattern with variations of effect: lines 30° with vertical.
No. 299. Pattern composed of arcs of circles with elaborated version.
No. 300. Pattern composed of arcs of circles and straight lines at angle of 45°.
No. 301. Fret pattern. Japanese.
No. 302. Fret pattern. Japanese.
No. 303. Moresque pattern.
No. 304. Counter-change pattern.

Patterns based on the Octagon.

No. 305. Patterns of interlaced octagons.
No. 306. Pattern of interlaced octagons.
No. 307. Patterns of interlaced octagons.
No. 308. Pattern of interlaced octagons. Persian.
No. 309. Pattern of interlaced octagons.
No. 310. Pattern of interlaced octagons.

The preceding six patterns are suitable for leaded glass.

No. 311. Indian all-over pattern based on the octagon.
No. 312. Moresque pattern based on the octagon.
No. 313. Counter-change pattern, constructional lines at angles of 30° and 60°.
No. 314. Arabian all-over pattern. The basic plan is a diamond, the angles being obtained by lines drawn through a circle divided into five equal parts as shown.

Patterns based on the Hexagon.

No. 315. All-over pattern. Persian.
No. 316. All-over pattern.
No. 317. Pattern formed of intersecting hexagons.
No. 318. Pattern formed of intersecting hexagons.
No. 319. Pattern formed of intersecting hexagons.

Patterns based on Circles.

No. 320. Inlay pattern. Byzantine.
No. 321. All-over pattern. Egyptian.
No. 322. All-over pattern, intersecting circles.
No. 323. All-over pattern, intersecting circles.
No. 324. All-over pattern, intersecting circles.
No. 325. All-over pattern, intersecting circles.

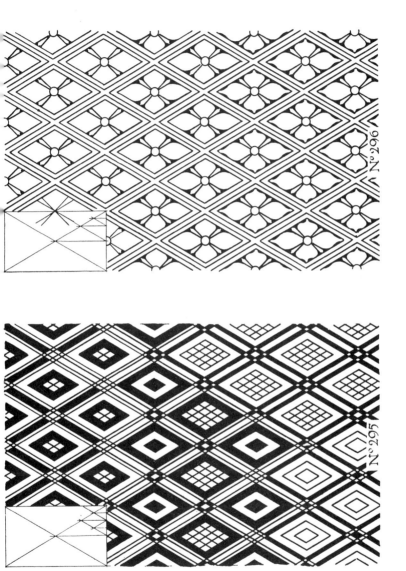

N° 296

N° 295

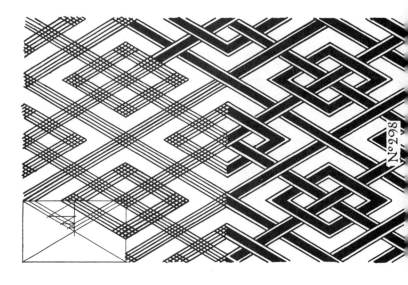

N° 298

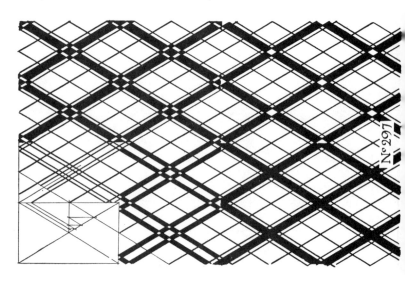

N° 297

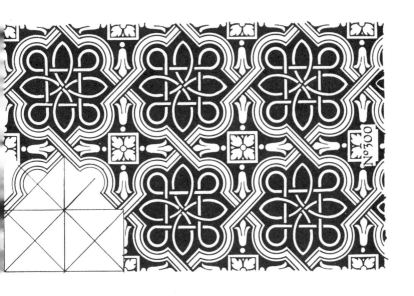

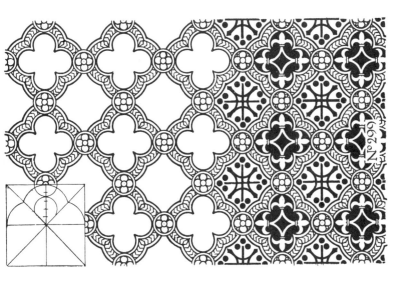

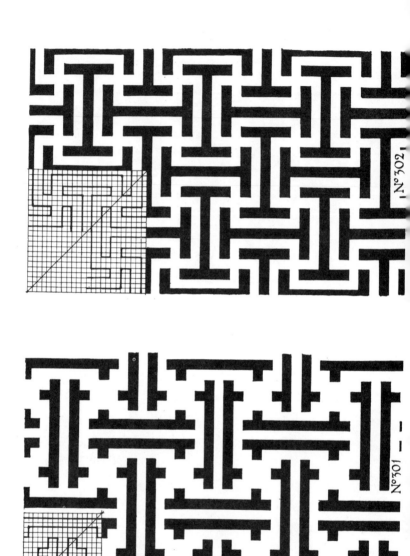

N° 302

N° 301

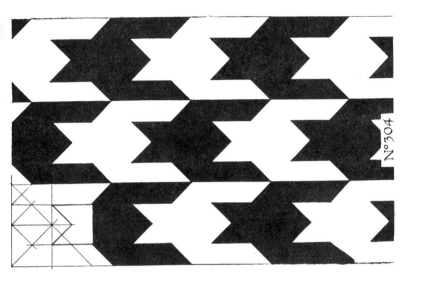

N° 304

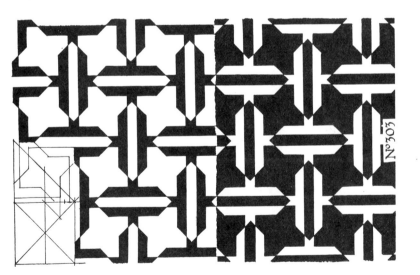

N° 303

129

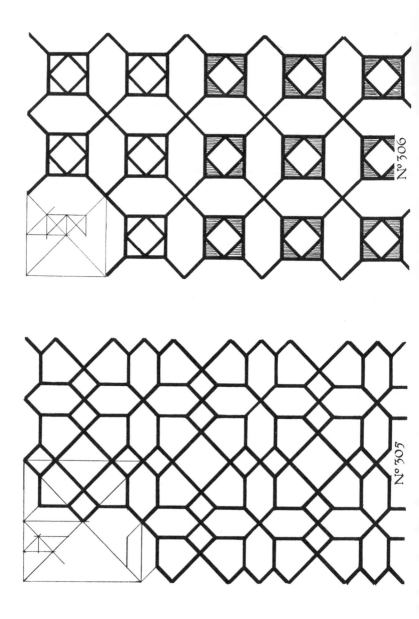

Nº 306

Nº 305

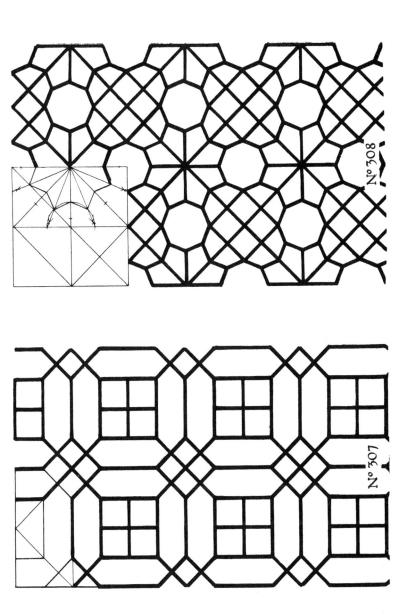

Nº 308

Nº 307

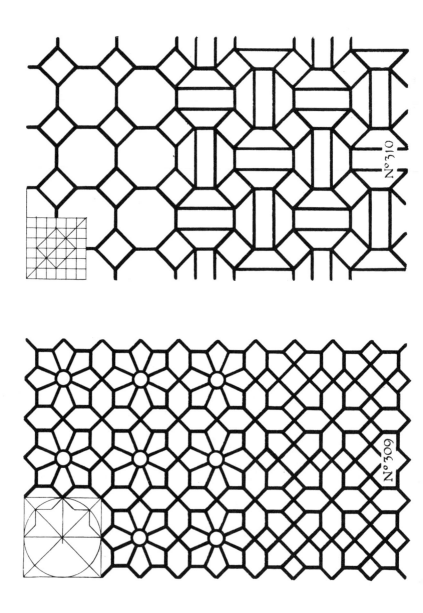

N° 310

N° 309

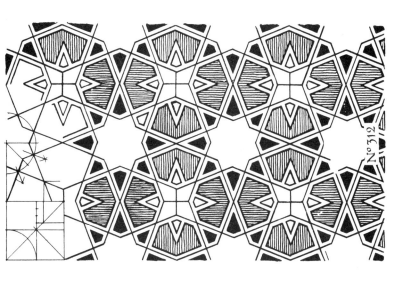

Nº 312

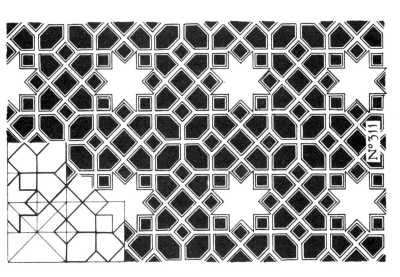

Nº 311

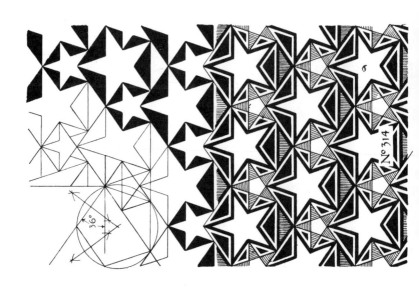

N° 314

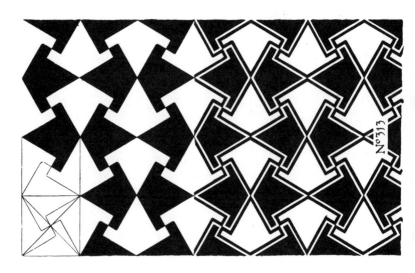

N° 313

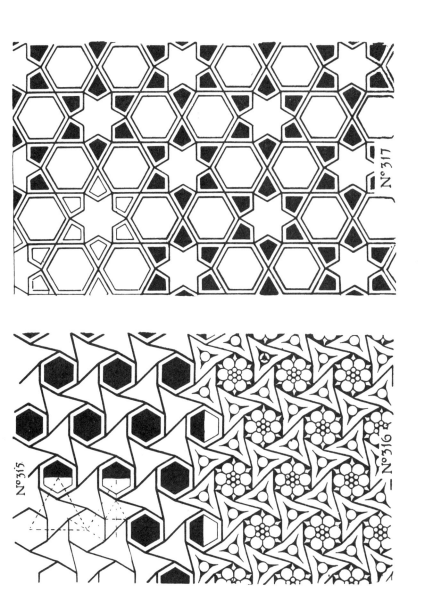

N° 317

N° 315

N° 316

135

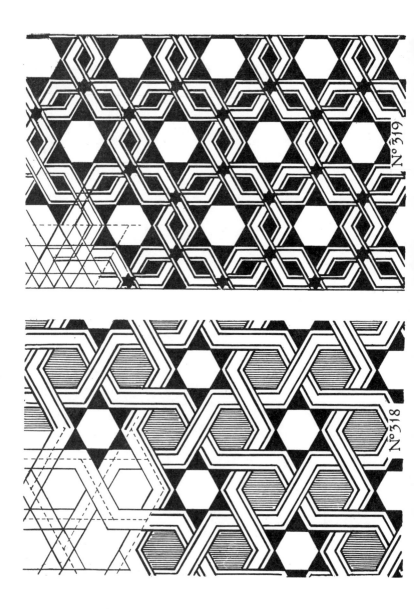

N° 319

N° 318

136

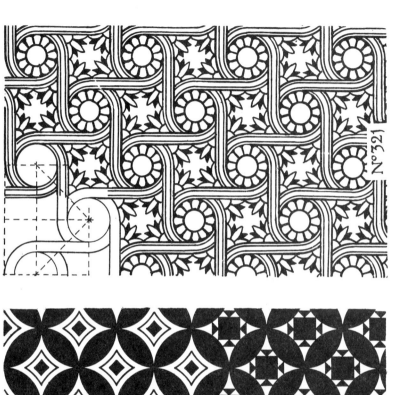

Nº 321

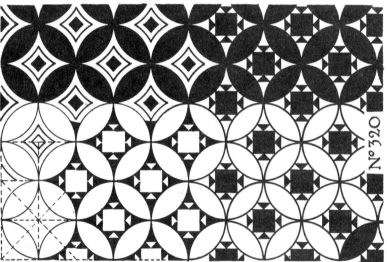

Nº 320

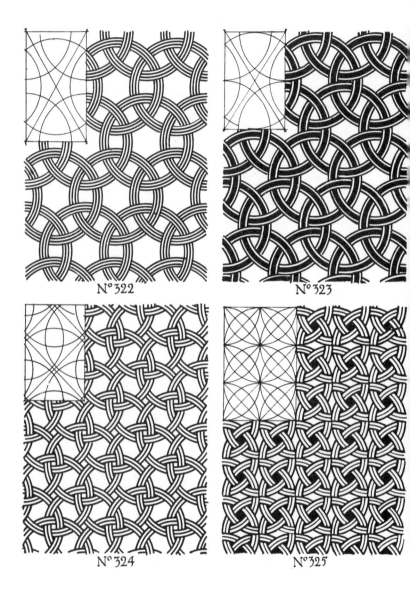

N° 322

N° 323

N° 324

N° 325

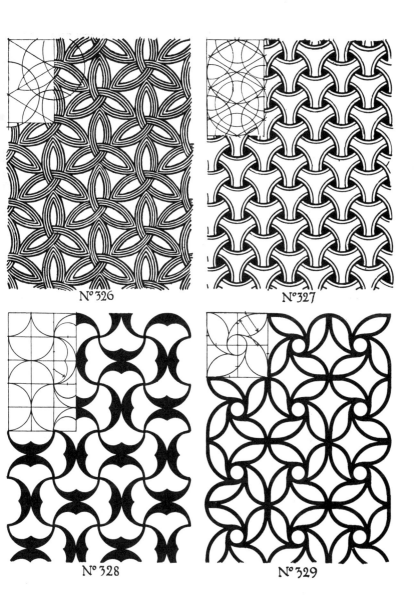

Nº 326

Nº 327

Nº 328

Nº 329

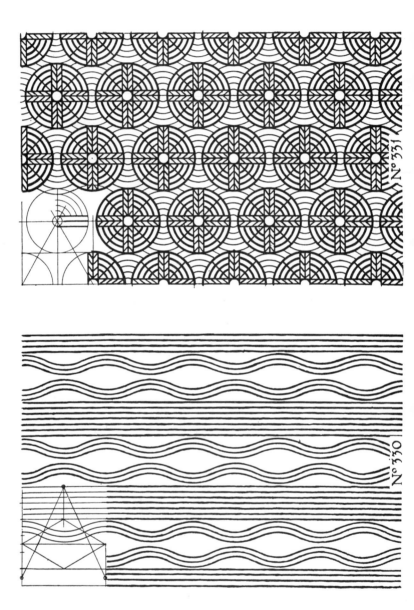

N° 331

N° 330

No. 326. All-over pattern formed by segments of circles.

No. 327. All-over pattern formed by segments of circles.

No. 328. All-over pattern formed by segments of circles.

No. 329. All-over pattern formed by segments of circles.

No. 330. Pattern of stripes alternatively straight and curved. Japanese.

No. 331. Pattern of concentric arcs of circles. Japanese.

> The preceding patterns are in the main the result of geometric drawing pure and simple, but the geometric form may be only a means to an end.

In No. 344, an Italian rendering of a Persian design, the predominant detail is obviously designed on a circle. Presumably the design is set out on geometric lines; the circle A is struck from the points of intersection of straight lines in the form of a trellis or diamond. The circle evidently controls the general form of the subsidiary detail B, and the leaf-like details are arranged concentrically. This constitutes the whole arrangement. In the final elaboration the geometrical shapes are modified and to some extent lost. The pattern is interesting as an example of conventional treatment. The detail in the larger circle is based on the pink, but the designer, while in no way affected by natural appearance, has embodied the character of the flower to some extent. Realistic effect is not merely impossible but undesirable in the weaving process by which the pattern was produced. The patterning on the leaf and flower-like details is a clear indication that the designer possessed a perfect knowledge of the process involved.

Similar geometric planning is evident in the Sicilian pattern No. 345. The introduction of what appears to be Arabic lettering suggests an Eastern origin. It is, however, imitative of earlier Eastern patterns, in which texts from the Koran frequently appear. It will be seen that this device repeated on a central axis is a concession to the weaving process.

Pattern No. 348 is an example of the geometric line being used as a means to the end, for it is disguised in the detail, which conforms to a series of semicircles arranged bi-symmetrically.

The use of geometric shapes is shown also in No. 349, but the circular forms are to some extent lost owing to the freedom of the detail.

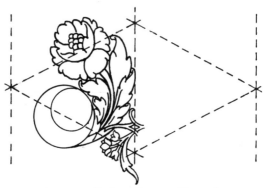

No. 332. Unit of Pattern No. 348.

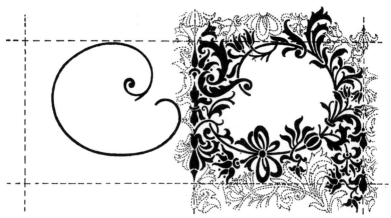

No. 333. Unit of all-over Pattern No. 350.

Types of Pattern Common to Textiles, Woven and Printed.

The All-over is generally a closely arranged pattern with the background equal in area to the details, and with no marked emphasis of form, direction, or colour. It is suitable when an unobtrusive effect is desired, and it has the advantage over a

plain surface that damage and signs of wear are not so obvious, and is therefore largely employed for wall papers.

Pattern No. 350 is a good example, though the contrast of black and white incidental to its illustration here is more assertive than it would be when produced, probably in quiet hues or shades of the same colour.

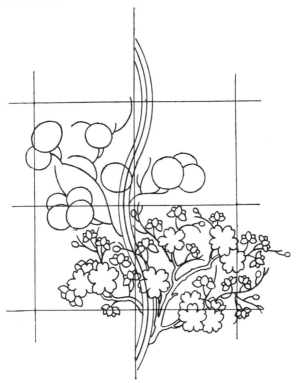

No. 334. Unit of Pattern No. 351.

The geometric basis is not directly evident. The pattern consists of elliptic-shaped stems bearing leaves and flowers and arranged bi-symmetrically. The plan of the unit is a rectangle, which can be determined by noting the recurrence of the same detail vertically and horizontally. The drawing of the detail is free-hand throughout.

Pattern 351 is an all-over with regard to the equal distribution

of detail, but it has a defined vertical direction in the stems. Though the general effect suggests variation, it really consists of a fairly simple unit; the elaboration is due to repetition.

The plan of the unit as shown in the diagram is a rectangle, and the undulate stems are formed of arcs of circles. This type of pattern, in which the growing stem is a conspicuous feature, is based on Chinese design, and has enjoyed great popularity in designs for wall-papers and printed textiles.

The vertical direction is not so marked in pattern No. 352, which consists of a tree-like growth with interstices occupied

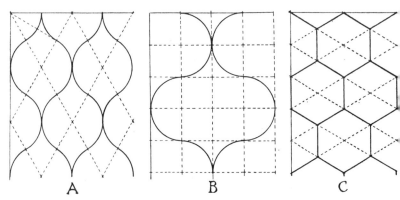

No. 335. Setting out of the net pattern.

by smaller detail. This subsidiary growth, while conducing to the appearance of an all-over, is also a valuable factor in effect.

The plan as shown is a rectangle—otherwise the design is freehand. The branches are drawn first, in order to secure a fairly equal distribution over the area of the unit. Both these and the groups of leaves radiate. The latter are about uniform in size, and this secures the desired contrast to the detail of the interstices.

THE NET PATTERN.

The net pattern is so called because it resembles a form of mesh. It is generally constructed on the diamond (A), though occasionally on a plan of squares as shown (B).

The net can also be formed of hexagons (C).

The lines of the net may be emphasized as bands, generally decorated, or can be used as stems.

Pattern 336 is a simple example of the net as the construction shows. It is in the main geometric in detail.

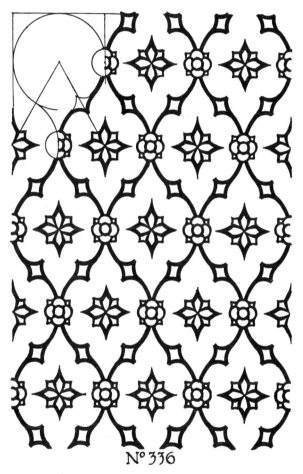

Nº 336

In Pattern 356 the line of the net is somewhat obscured by the dominant leaves. The directions of these, however, follow the lines of the struck circles. The enclosed spaces are filled with small floral detail, the main stems of which form an intersecting net.

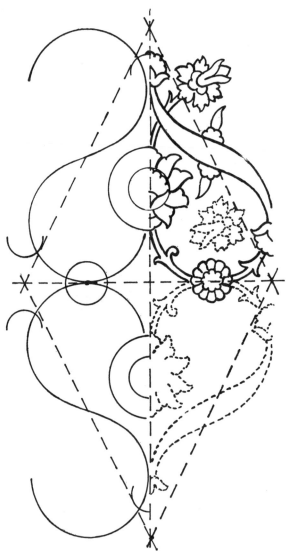

No. 337. Unit of Pattern No. 358.

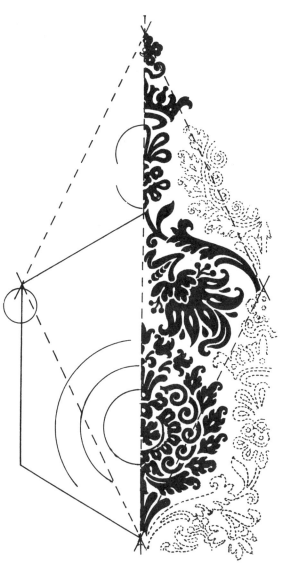

No. 338, Unit of Pattern No. 359.

A reversed treatment is shown in No. 357, seventeenth-century
Persian design. Here the enclosed areas give the dominant shapes
and the net is emphasized by relatively small detail based on the

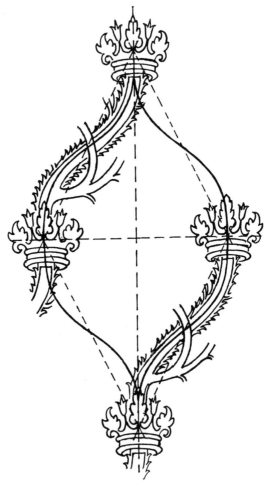

No. 339. Unit of Pattern No. 361.

pomegranate. Though elaborate in effect, the design is very simple
and it is a beautiful example of conventional treatment and of
patterning on pattern.

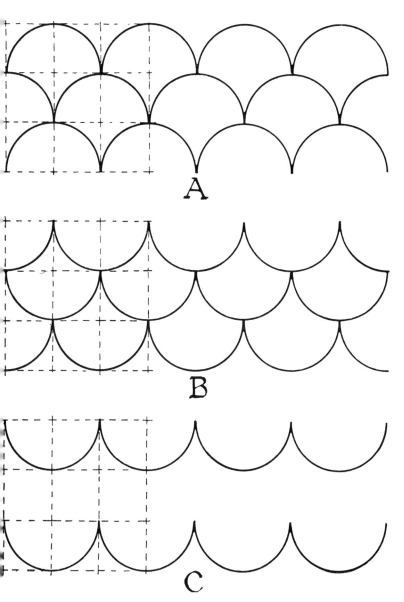

No. 340. Construction of scale patterns

In No. 358, another Persian design, the unit is even simpler. The lines of the net are more slightly defined, but the construction is obviously geometric.

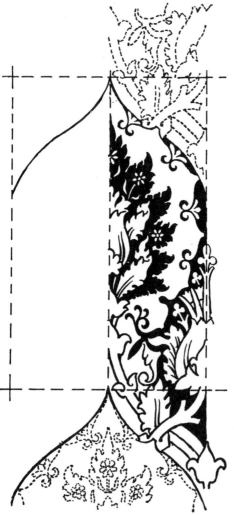

No. 359 is from an Italian woven fabric of the seventeenth century. The net lines are not so emphatic, though the direction is easily traced and the curves do not conform to a circle. Probably it was designed on a hexagonal plan.

The detail is Renaissance, but strongly reminiscent of the Eastern influence in the early Sicilian patterns. Variations of this type of pattern are often used in modern tapestry designs.

No. 360 is a modern wall-paper design obviously imitative of tapestry. The bands of the net are decorated with branching foliations which break the monotony of the lines. The rosette in the enclosed shape is placed above the centre, this avoids unpleasant alignment with the detail clasping the bands.

No. 341. Unit of Pattern No. 362.

No. 361 is a late sixteenth-century Italian design, and a type very prevalent in the fifteenth and sixteenth centuries. It is planned on the net, but

he meeting bands are omitted, with the result that an oblique
direction is strongly marked by the remaining bands; these are
conventionally treated as stems, and the balance is restored by
dominant details crossing them in the opposite direction.

SCALE PATTERNS.

Scale patterns may be formed by overlapping semicircles as
indicated on page 149.

In No. 362 (C) is used, but the curves, although geometric,
are flexed or ogival, and are struck from two centres as shown in
he construction. This pattern is from the Ransworth Screen,
where it is used as a painted decoration, but it is probably taken
from a Flemish design of the sixteenth century, and is an excellent
example of the conventional treatment of the period.

THE STRIPE.

The term is obvious. Stripes may be merely an association of
lines and plain bands, or may consist of detail arranged in a
similar manner.

No. 363 has foliated stripes of conventional floral detail
separated by plain lines and bands, and is a repetition of Border
No. 253.

THE SPRIG.

The term sprig can be properly applied to any pattern which
consists of separate sprays or sprigs of foliage. The spray should
be open and ramifying. If closely arranged, it may become a mass
shape and come in another category "the Spot" as Pattern
No. 365. Both Sprig and Spot patterns are often treated with
subsidiary detail such as small leaves and flowers, and even mere
dots—generally termed "powdering."

The detail of No. 364 is based on the circle, struck from the
points of intersection of the diamond on which it is planned.

The detail of No. 365 also conforms to the circle, the centre of
which is indicated. The plan is again the diamond,

The Trellis.

The trellis also explains itself. It consists of intersecting lines or thin bands crossing the pattern either vertically and horizontally, or obliquely, and traversed by floral detail, generally of a light and open character.

In many instances border details lend themselves to all-over patterns.

An example is given in No. 366 of Border Design No. 249 as a side-to-side repeat.

No. 367 is the same detail arranged as a half-drop.

No. 368 is really a net pattern arrived at by arranging the detail of the same border reciprocally.

No. 369 also shows the net plan. This is Border No. 248 arranged similarly to the preceding pattern, though the defined space dividing the floral detail gives it rather the suggestion of a stripe effect.

No. 370 is Border No. 245 arranged as a half-drop.

No. 371 is a similar treatment of Border No. 251.

The borders selected as these all-over patterns are all designed on the undulate line, which is an important factor when continuity of pattern is desired. They may not be wholly satisfactory in the original form, for there is a tendency to a defined line or space when repeated as suggested. This can be overcome by a little exercise of the imagination. A greater unity of effect may be imparted by breaking the undesirable spaces by extending detail across these at intervals. They are illustrated, however, merely as demonstrations, without such modification.

Patterns Nos. 372 and 373 both consist of undulate stems, and are suggestive of net patterns. The former is a modern printed cotton based on Persian details, and the latter is an old Persian textile design. The curves in both are constructed geometrically.

The undulate line is also used in the composition of No. 374, in which the separate sprays of leaves are arranged on arcs of circles. The construction is shown.

In designing a pattern for a process of mechanical production,

uch variety as is used must obviously be confined to the essential unit, and restraint with regard to forms, and their colour and treatment must still be observed if the pattern is to be satisfactory.

Besides the considerations of utility or purpose, and the imitations imposed by the method of production, the suitability of the unit for repetition is of great importance.

A tapestry may be used for hangings or for upholstery. If the latter, the pattern is usually the result of a small unit of simple

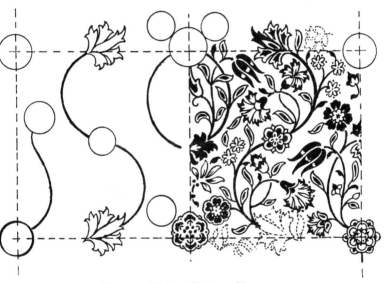

No. 342. Unit of Pattern No. 372.

form, or a panel-like unit on a powdered or textured ground. The advantage of the small unit is that the pattern does not suffer greatly from mutilation when it is cut into the various shapes in which it may be required.

Designs for hangings can be less formal, but the limitations of the process must be taken into account. Curves should be bold, as slight curves will be affected by the inevitable stepping in the weaving. Curves that approximate to segments of circles are better therefore than those tending to be elliptical. Vertical stripes,

or indeed any marked vertical direction that is an essential
feature of the design, should be avoided for a material that is to be
hung in folds, as they may be lost or greatly obscured. If stripes
are a feature, they may be arranged horizontally or obliquely.
For material that is to be displayed flat such stripes might mark
a direction too insistently, but if it is to be hung in full folds

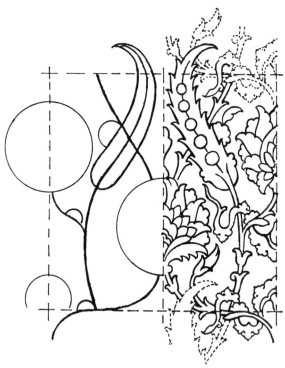

No. 343. Unit of Pattern No. 373.

they are effective, as the formality of the stripes is modified into
curves by the undulations of the material.

Cotton-printing was originally a cheap imitation of tapestry,
and cretonnes are in the main much the same in design, but are
usually more gay and varied in colour.

Designs for wall-papers should be more restrained, though they
have also been imitative in the past. Some early wall-papers, of

which a few examples survive, were strips or panels of Chinese design and execution. These were not mechanically produced, except perhaps that they were probably partly stencilled. They were introduced into England in the seventeenth century. The design was not a repeating pattern, though the paper was in strips, which when joined together covered the wall. The subjects were mostly renderings of landscapes.

These were imitated in England during the eighteenth century, and were in the main repeating patterns, the outline being printed and the various colours applied by hand. This is a type of design which has survived, and appears not only in wall-papers but in cretonnes.

The design of a wall-paper should be influenced by its subsequent employment—mainly whether it is to be displayed as an unbroken surface, or whether it is to form a background for pictures, etc. If the latter, the pattern should be inconspicuous.

Wall-papers and certain textiles are printed, the better qualities by hand from wooden blocks, and the cheaper from rollers. In roller-printing, in many instances, the lines of a pattern are formed of strips of metal embedded in the wood; owing to the uniform gauge of the metal, the result is lines of unvaried width, which are hard and unsympathetic in effect. A more interesting and less mechanical result is obtained from a hand-cut block or roller. The lines are generally stronger and can be varied in thickness, thus imparting a richer effect to the pattern. For cheaper production than is possible with wooden rollers, metal plates are used. The results from these are comparatively ineffective, the method, however, enables colours to be graduated and merged with greater facility than do the other processes; this is to be deplored, but fortunately the crime brings its own punishment.

In printing, each colour requires a separate block or roller. The pigments used for wall-papers are mostly opaque, but for textiles they are transparent. In the latter, therefore, the colours can be modified by over-printing, giving opportunities for more complicated effects. Thus, yellow over-printed on blue will result in green. Surface interest can also be imparted, and effects of graduated colour within certain limitations. Obviously each colour

must have a definite boundary, but merging of colour may be
obtained by tapering lines or some form of stipple. Over-printing
can be effectively employed in patterning leaves and flowers
with further detail, which, however, must be carefully considered
as forming part of the design.

In the weaving of tapestry every distinct colour employed

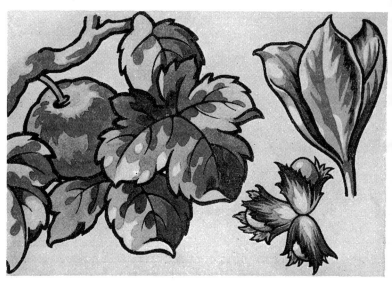

No. 343A. Surface interest in pattern on form. Suggestion may be derived
from light and shade, striations, and markings on flowers and
leaves, but should be decorative in treatment.

must be a separate thread, but these may be arranged to give
more complex effects by interweaving with others. This is analo-
gous to over-printing in cretonnes.

The number of different colours employed in textiles and wall-
papers varies considerably, but the use of any colour should
be justified by being distributed fairly equally throughout the
design.

Description of Textile Patterns.

No. 344. Italian rendering of a Persian design. Dominant detail based on the circle. Diamond plan.

No. 345. Sicilian pattern showing Mohammedan influence. Dominant detail based on circle. Diamond plan.

No. 346. All-over pattern suitable for ceiling-paper. Detail controlled by semicircles struck from angles of squares.

No. 347. All-over pattern of Persian origin. Detail controlled by circular curves. Diamond plan.

No. 348. Conventional floral pattern. Main details controlled by circular curves. Diamond plan.

No. 349. Floral pattern. Dominant details controlled by circular curves. Diamond plan.

No. 350. All-over pattern. Rectangular plan.

No. 351. All-over pattern. Rectangular plan.

No. 352. All-over pattern. Rectangular plan.

No. 353. Drop pattern. Rectangular plan, undulate stems segments of circles.

No. 354. Sprig pattern. Details controlled by circular curves. Diamond plan.

No. 355. Conventional floral pattern in which circle is dominant. Diamond plan.

No. 356. Net pattern. Small detail subordinated to large. Diamond plan.

No. 357. Net pattern. Seventeenth-century Persian design. The "net" formation is strongly defined by Pomegranate detail. Diamond plan.

No. 358. Net pattern. Persian design, though obvious the "net" is not connected throughout. Diamond plan.

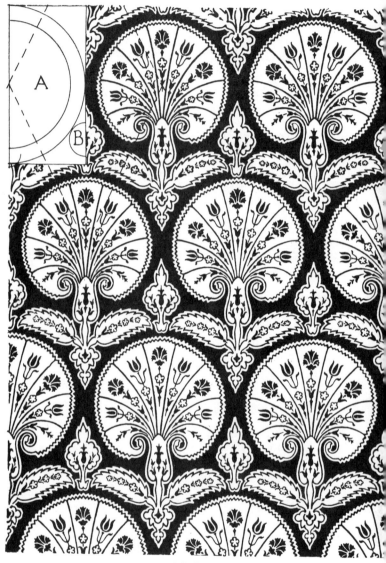

N° 344

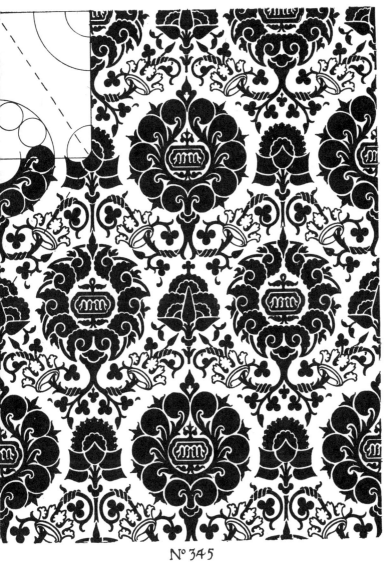

Nº 345

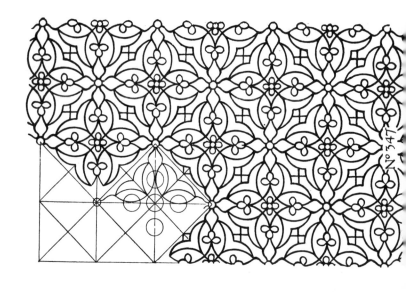

N° 347

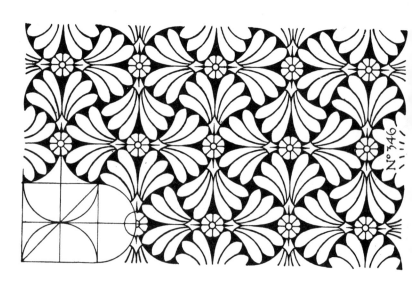

N° 346

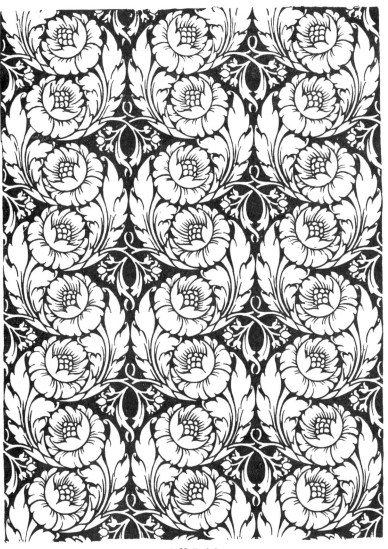

N° 348

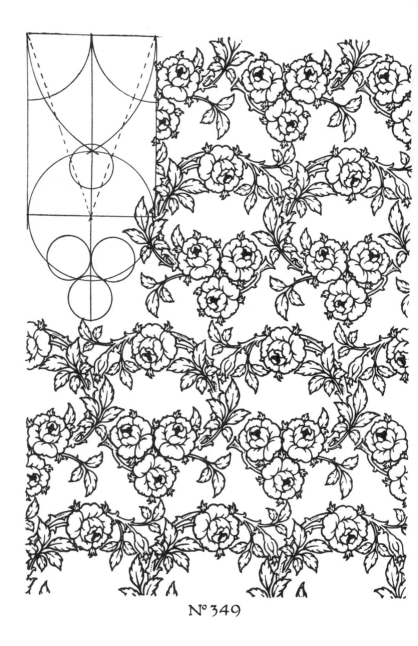

N° 349

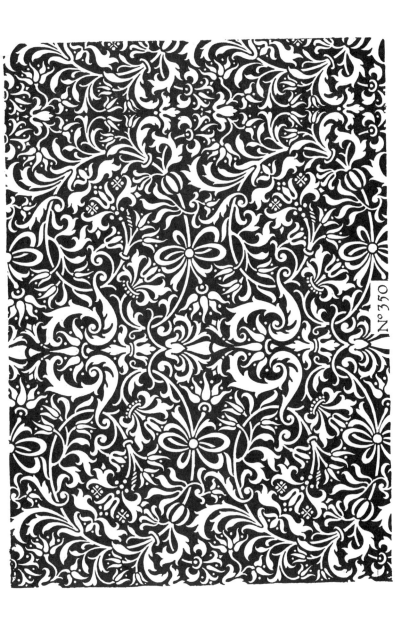

Nº 350

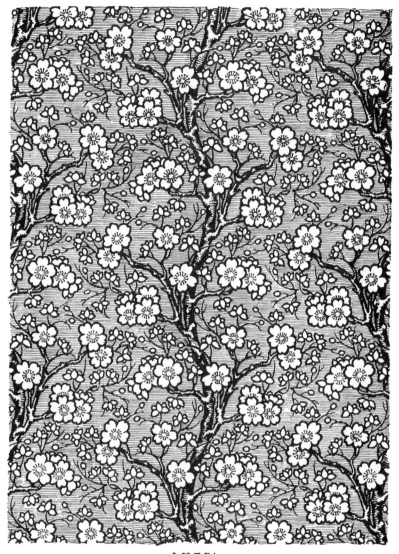

N° 351

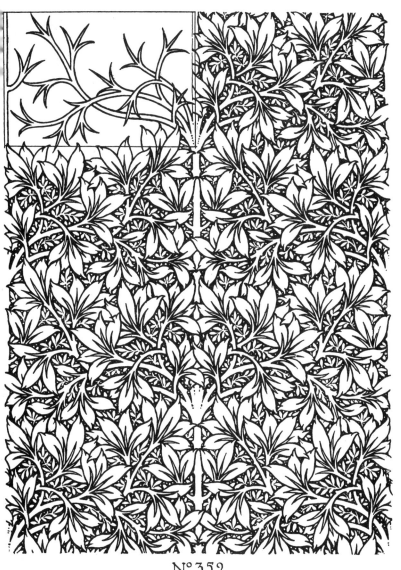

Nº 352

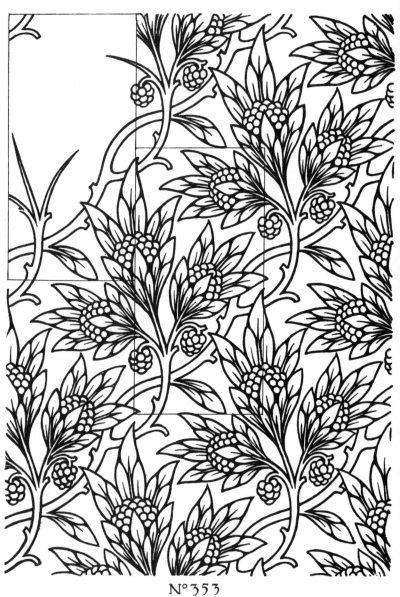

N° 353

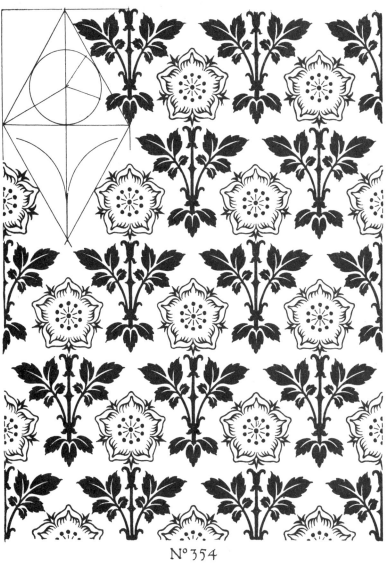

N° 354

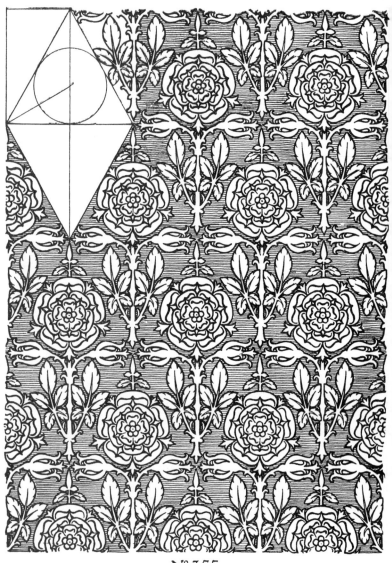

N° 355

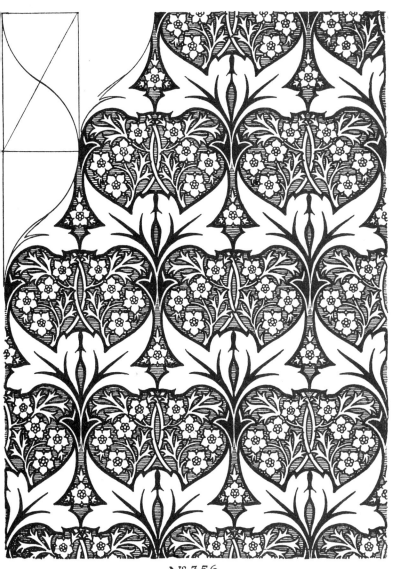

Nº 356

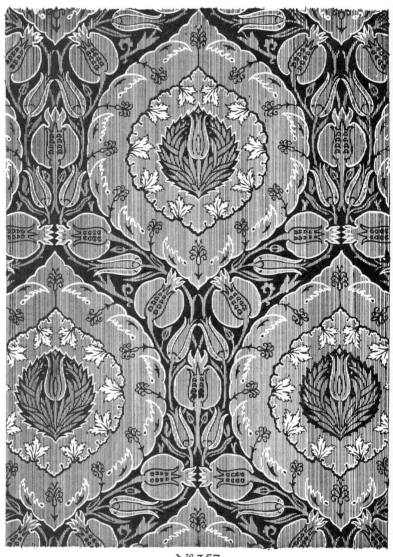

Nº 357

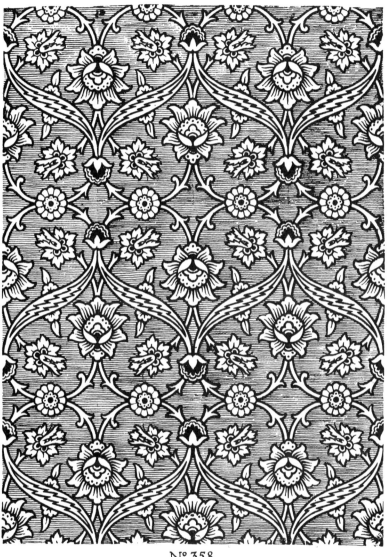

N° 358

No. 359. Net pattern. Italian seventeenth century. In this the "net" is based on lines at angles of 30° with horizontal. Diamond plan.

No. 360. Net pattern. In this instance the net is emphasized by taking the form of decorated bands, the formality of which is to some extent broken by the small sprays of foliage. Diamond plan.

No. 361. Sixteenth-century Italian design. The construction is that of the "net," but the bands are not repeated reciprocally. Diamond plan.

No. 362. Scale pattern. The plan of unit is a rectangle.

No. 363. Stripe pattern. Repetition of Border No. 253.

No. 364. Sprig pattern. Detail controlled by circles. Diamond plan.

No. 365. Spot pattern. Detail controlled by circles. Diamond plan.

No. 366. Pattern on undulate line, side-to-side repeat. Repetition of Border No. 249.

No. 367. Pattern on undulate line. Half-drop repeat. Repetition of Border No. 249.

No. 368. Pattern on undulate line. Reciprocal repeat on lines of net. Repetition of Border No. 249.

No. 369. Pattern on undulate line. Reciprocal repeat on lines of net. Repetition of Border No. 248.

No. 370. Pattern on undulate line. Half-drop repeat. Repetition of Border No. 245.

No. 371. Pattern on undulate line. Half-drop repeat. Repetition of Border No. 251.

No. 372. Modern pattern showing Persian influence. The arrangement is on the net. The plan, however, is a rectangle.

No. 373. Old Persian design. The plan of unit is a square.

No. 374. Pattern on undulate line. Curves struck from centres as shown.

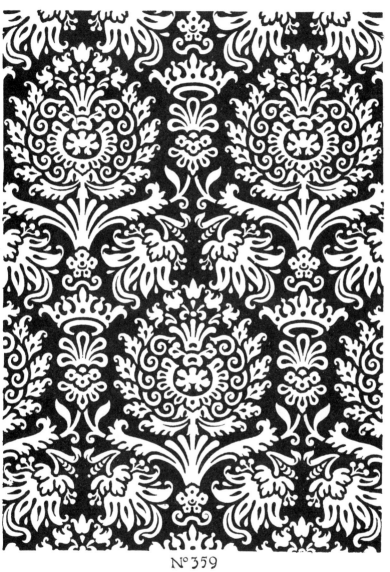

N° 359

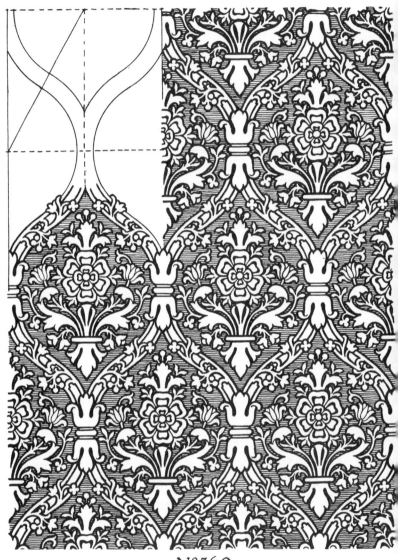

N° 360

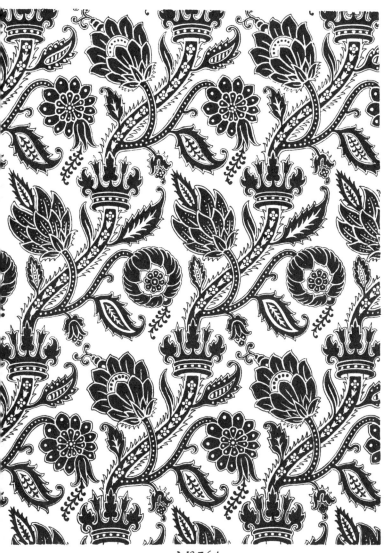

N° 361

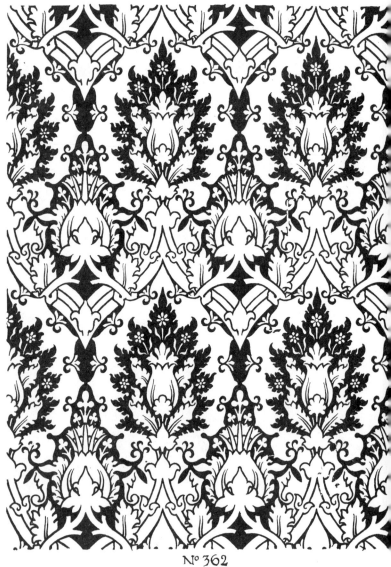

Nº 362

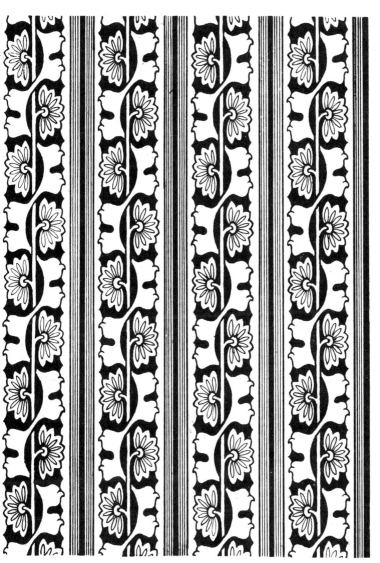

N° 363

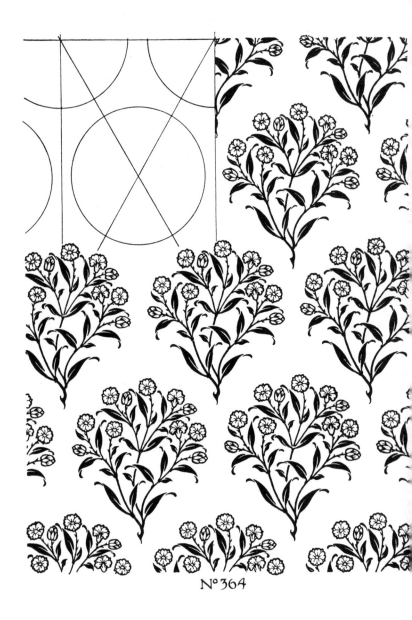

Nº 364

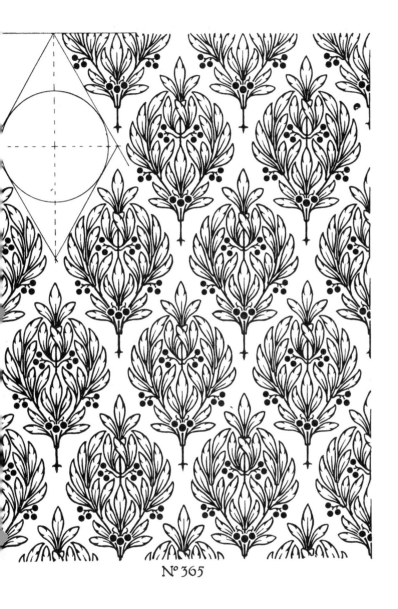

Nº 365

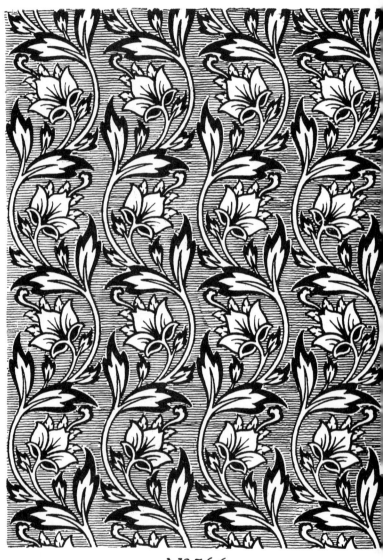

Nº 366

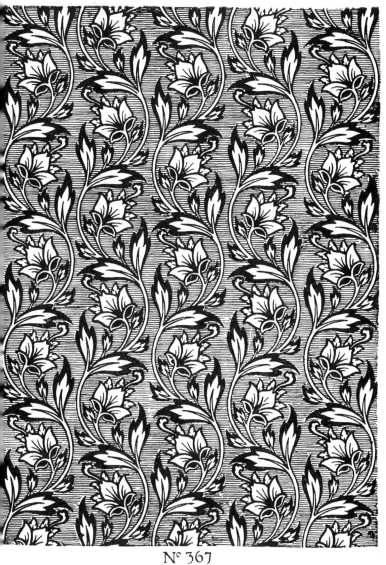

N° 367

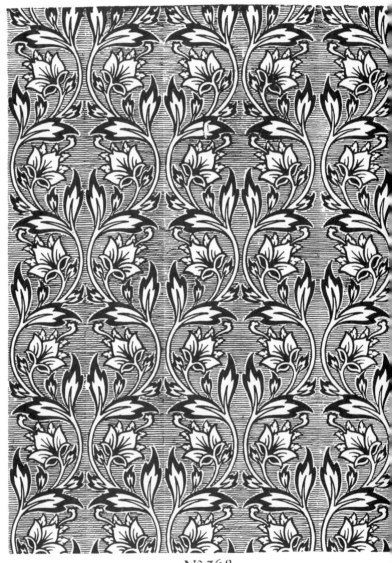

N° 368

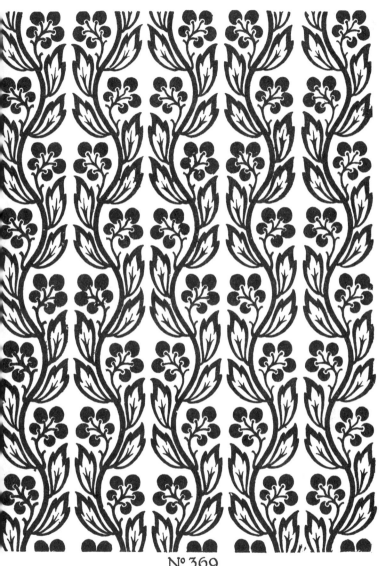

Nº 369

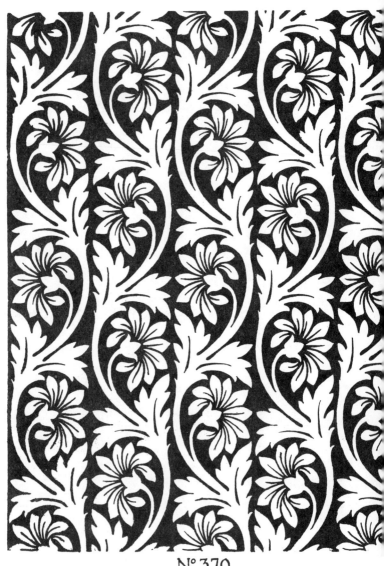

Nº 370

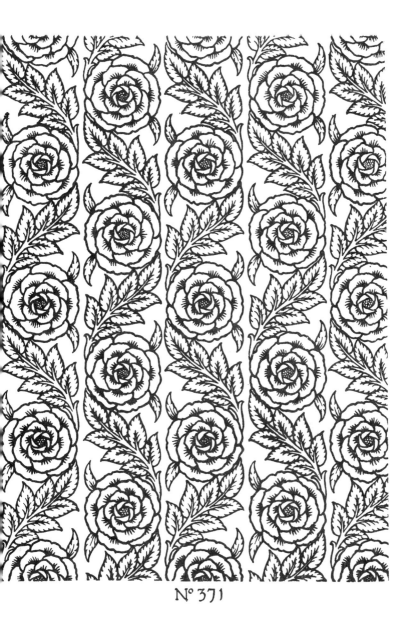

Nº 371

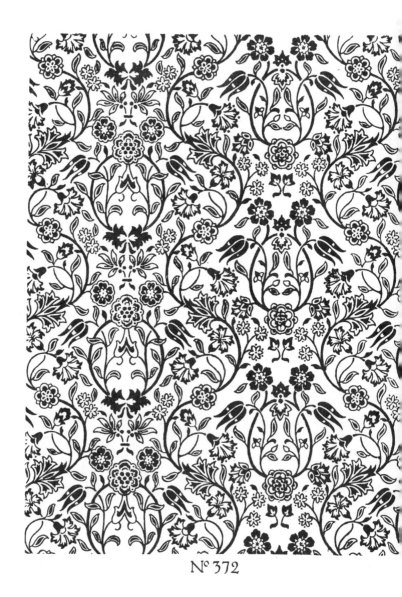

Nº 372

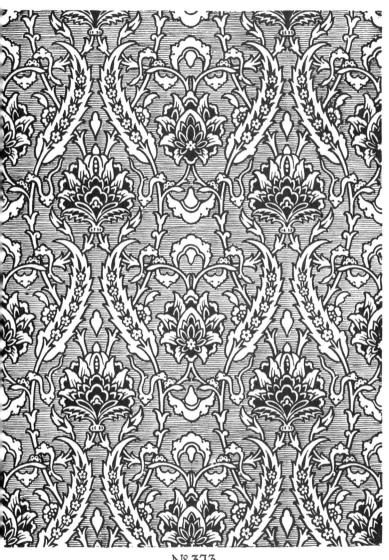

Nº 373

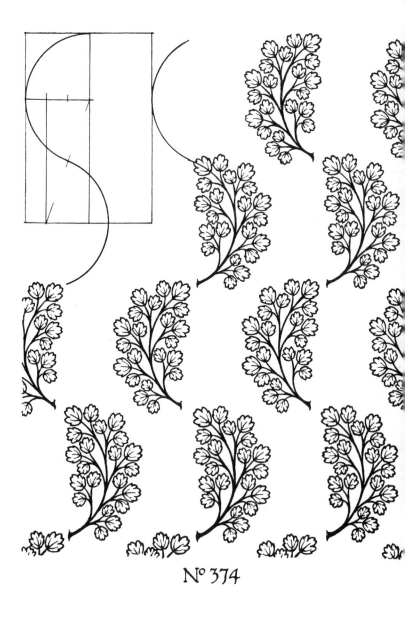

N° 374

CHAPTER V

NATURE STUDY AND TREATMENT

THE possibilities in design are endless, the whole range of natural forms are at the choice and discretion of the designer, and the study of Nature is not merely advisable, it is imperative. Notwithstanding the wealth of material, it is inevitable that the same types should be used over and over again, and it is doubtful if there is anything to be found in Nature that has not at some time or other been exploited.

The object of Nature study being to obtain material for design, the method of procedure should be comprehended by the student. Studies should be analytical, the main consideration is form and structure; colour may be interpreted, but form is more important. A realistic treatment in the direction of illusion is not the best for the purpose—there is no obligation on the designer to exploit Nature in this way—the object is to obtain detail which can be turned to satisfactory account. The young student often finds it difficult to see decorative possibilities, and the bane of Nature drawings is the tendency towards undesirable realism when used as design. A spray of foliage, even if well drawn, that is merely a rendering of natural appearance, may be unsuitable in design, particularly in a repeated pattern; it is also a very cheap expedient. Design is intentional arrangement, and the study of natural form to obtain detail is a means to an end.

A repeating pattern in which the detail suggests realism is also irrational, since the iteration of the same forms and attitudes is utterly opposed to the endless variety of Nature. There are also technical reasons which render natural effects impossible, and for these alone such treatment should be avoided. A great part of the designer's art consists of selection, that is, in the choice of suitable forms, attitudes and aspects.

If a spray of foliage is the subject for study, it should be carefully considered from various points of view. Balance and silhouette are the primary considerations. Quite apart from the final expression in whatever material, the silhouette is of paramount importance. A view-point should therefore be taken that displays the spray to the best advantage. It is rare that any example is ideal, and discretion has to be exercised to get the best results.

For instance, leaves or stems may be undesirably parallel or so fore-shortened as to be confused in effect. Fore-shortening is not as a rule a favourable attitude for use in flat pattern design and though the forms might be elucidated by the employment of light and shade, they can be turned to better account by shifting the view-point until a more suitable attitude is obtained. It can be taken for granted that if the particular shape is a good silhouette that is, if it explains itself as such, it is safe as pattern. The tendency to too much parallelism can be dealt with by slightly varying the angles. Such editing is not only permissible but extremely useful, and demonstrates the selection necessary for the designer. Crossing and interlacing of detail imparts unity to a design, but should be definitely contrasting in direction; the angle of approaching details should be similarly decisive, otherwise the effect will be weak. There is always an impression of feeble apology when lines approach each other, then turn aside as if to avoid collision. Presuming the arrangement has been considered, as suggested, attention should be paid to form, structure and particular characteristics. Important points to notice are the articulations of branches, leaves and flowers. The drawing will probably be more explanatory if executed in line. Light and shade is not as a rule necessary, but may be helpful to explain fore-shortening, which, however, is only desirable when such an attitude forms a good silhouette.

Colour may be used, but rather as a suggestion than an attempt to realize the natural appearance.

In short, the energy of the student should be devoted to recording all details that suggest pattern, or may in any way be helpful or relevant to the purpose.

A good way to set up any flowers or foliage intended for study

A

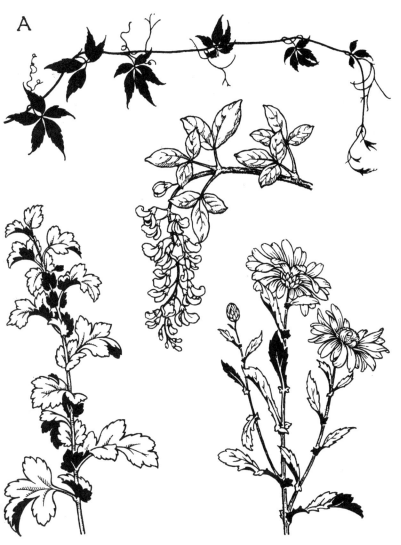

No. 375. Studies from Nature in which the silhouette is the primary consideration. A is from a direct brush-drawing by a student in the Training Department of the Goldsmiths' College.

is to embed part of the stem in modelling clay, placed either on the table or a board in a vertical position. This enables the model to be seen in its natural attitude—which is important—with no part suffering from compression. Also, the damp clay will serve for the time being to keep the specimen fairly fresh.

Nature studies should not be regarded merely as exercises in drawing, or as useful only for the immediate purpose, but should be kept for future reference; but it need not be taken for granted that any natural form so studied is sufficiently recorded; on the contrary, it is generally possible to see something fresh in the same type which may at any time become a subject of interest.

Any natural growth can with advantage be studied at progressive stages of its development through its whole life period, and, obviously, such drawings should be classified.

Although it is not desirable in design to represent natural form realistically, yet a certain consistency to natural growth should be observed. Even in purely conventional ornament, if the detail, though not recognizable as any natural type, consists of stems bearing leaves and flowers, the principle of growth is generally observed. Consistency to type may be regarded as an obligation when the detail can be identified with any particular species, both as regards forms and attitudes, but may be relaxed in proportion as the ornament becomes more and more purely conventional.

It is suggested that the immediate use of the study from Nature should be that from it the student should deduce conventional renderings. Leaves, flowers, etc., should be rendered in a way suitable to form pattern; their arrangement as a design need not be attempted at this stage.

To express a form in outline is the readiest convention, and this should not be taken literally from the study unless unmistakably suitable. The elimination of accident and the simplification of detail are generally compatible with a decorative effect.

The striations on flower petals, veinings on leaves, and any other markings that have been recorded, may be of assistance in the conventional rendering. The outline may be much thicker than would be employed in drawing generally. It would be a considerable help if some form of reproduction were considered:

for instance, a detail suitable for printing from wood blocks, or a practical design for a stencil, with the consideration of the essential ties; the conditions imposed in both cases assist and suggest conventional treatment.

To represent detail in flat colour is also a convention; if, as as may be necessary, spaces are left to define the detail more precisely, it is akin to stencilling, but not so restricted in a technical sense. Conventional renderings of the studies from Nature will, in addition to providing details and treatments which later can be incorporated in design, exercise imagination, give an opportunity for experiment, and practice in clean execution. They can be in black and white or in colour—preferably outlined with the brush—and the effect should be tried of the same detail on dark as well as on light grounds.

It will be understood that the natural effects of colour in designs for any mechanical process are impossible of attainment, but may of course be a general guide. There is no obligation, however, to follow natural colouring; for instance, it is permissible, if justified by the conditions, to adopt any colour scheme that is harmonious.

The judicious use of colour is a matter of experience. Its employment in interior decoration involves a knowledge of the actual conditions of area, aspect, and purpose. The designer of textile and wall-hangings in the ordinary way can only produce designs to appeal to the public taste, and the suitability of them to their environment is the responsibility of those who select. To assist the public in their choice, manufacturers produce each design in a range of colourings. In such circumstances it is only possible to aim at producing a good effect by the harmonious relation of the colours employed.

Patterns in a single colour on a white ground or the reverse produce a good effect as for instance, a quiet low-toned blue, such as is often used in china and pottery ware. Self-colouring, that is tints and tones of the same colour is safe, though not very venturesome. When more than one distinct colour is used the question of harmony has to be considered.

It is probably common knowledge that there are only three primary colours, red, yellow and blue; and a general guide to

the neophyte is that no two of the primaries can be harmoniously associated without the presence of the third. Thus pure red and blue will not harmonize, neither will yellow with either; but a secondary colour—the result of a mixture of any two primaries—will be in harmonious relation with one pure colour. The secondary colours are known as complementaries. Green, a mixture of blue and yellow, is the complementary of red. The complementary of yellow is purple—a mixture of blue and red; and the complementary of blue is orange—a combination of red and yellow. This can only be a general guide: the question of intensity and proportion of each is one of considerable complexity.

Red is the most violent colour, and consequently should only be used in comparatively small amounts. Blue and yellow can more safely be applied in larger areas; but pure colour, that is colour of full intensity, is seldom employed, certainly not in large patches. Although tints and tones are more generally used, the principle remains the same, and the endeavour should be to preserve the relative balance. If a complementary is associated with a tint or tone of a primary, the intensity of the one should be on the same scale as the other: that is, the comparative remoteness from the full primary intensity must be taken into account. The respective areas of the different colours have also to be considered, but the general safe rule is that the larger the area the more remote it should be from the original pure colour, whether primary or secondary.

In deciding a colour scheme the larger areas should be the first consideration, and the other colours chosen in harmonious relation.

It will be readily discovered by experiment that the correct complementary will brighten the colour with which it is associated, whereas if the rule is disregarded and colours improperly juxtaposed, they will only dull each other. For flat-pattern designs, opaque or body colours give the best results, as they can be applied slowly and yet dry flat—an effect which is sometimes difficult to achieve with transparent water-colour. Opaque colours, usually called Poster colours, can be bought. In the main they are cheaper than ordinary water-colours; some of them are more transparent than others, but these can be rendered equally opaque by the addition of white.

With these colours the work can be done if necessary on tinted paper or card, for, being opaque, the result is the same as if used on a white surface; also over-painting is possible, and this is extremely useful in design. Opaque pigment should not be used as thinly as transparent colour, but must be diluted sufficiently to flow easily from the brush; a little practice will determine the right amount of dilution. Fusion, or softening off of colour, to which transparent colour lends itself, is not readily achieved; but this is not important in flat-pattern designs where a well-defined edge is generally required. For most ordinary work cartridge paper or card will be found suitable.

DRAWING FOR REPRODUCTION.

Designs for book-decoration, such, for instance, as title pages, initial letters and head and tail pieces, are generally drawn in black and white, from which the blocks for printing are made by a photographic process. The blocks commonly used are in line and in half-tone. The former is the cheaper process, and the block is the result of a pen-drawing in black ink on white card or paper. All tonal effects are the result of lines, which may vary in thickness and in spacing. The half-tone block is made from a drawing executed by the brush in washes of black of differing dilution according to the effect required.

Drawings for reproduction by a photographic process are as a rule made larger, and reduced by photography to the required size. They should not however, be too large—a reduction of one-fourth or one-third will be satisfactory.

In pre-process times drawings for reproduction had to be the exact size, entailing at times minute detail.

The present-day artist is able to draw freely with a pen of medium point to a larger size, depending on the reduction for delicacy of line; for many purposes a fine writing-pen is good enough.

When making a drawing for reproduction proportion is important, and is more accurately arrived at by the diagonal method than by measurement. Given the size to which the drawing is to be reduced as it would appear when printed, this should be drawn

accurately as to width and height. A diagonal line is then drawn through the opposing angles and produced beyond; then any line parallel to one of the sides and returned at its intersection with the diagonal will give an area of exactly the same proportion as the original. It is obvious that a reduction can be made by the same method.

In speaking of reduction or enlargement, linear dimensions are always understood—not area—thus if the reduction is to be one-half, it means one-half the height and one-half the width, really a fourth of the area. One-half the latter would be a different proportion, which can be demonstrated by folding a sheet of paper in halves. A reduction of one-half implies a drawing twice the linear measurements; that of one-third an addition of one-half; and that of one-fourth an addition of one-third.

In indicating reduction there may be confusion as to the meaning unless clearly stated.

Probably the safest method is to indicate in pencil on the drawing one of the actual dimensions—either height or width, with the words "reduce to"; if arrow-heads are used and mark clearly the extremities, there is no possibility of error.

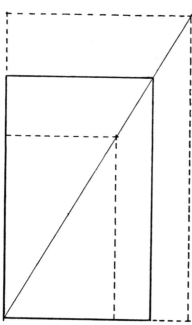

No. 376. Diagonal method of enlarging or reducing. Dotted lines show result.

A practical drawing for reproduction should be a clear statement in black and white. The block-maker is occasionally blamed for alteration of values and thickening of lines. The former is liable to occur if the reduction is too great—one-third is generally as much as is necessary.

Lines may be thickened in the printing, but this is due to faulty adjustment in the press. As a rule, the block-maker can be relied on to reproduce a drawing fairly faithfully within the limitations of the process.

It is much more likely that an inexperienced draughtsman will be disappointed by the extremely thin lines of the reproduction, due to overlooking the fact that as the drawing is reduced, so is the thickness of line in relative proportion.

Occasionally one hears that "cross-hatching" should not be employed in a pen-drawing for reproduction. There is no technical reason against it—it is merely a matter of taste. The direction of lines and how they are associated has no effect technically: any drawing will reproduce by the process if the lines are distinct with clear intervals between them. As previously stated, the ink should be solid black, otherwise the lines may not be equally dense. It was customary before the days of process reproduction to use different

←——— REDUCE TO 3¾" ———→

No. 377. Safe method of indicating required reduction.

dilutions of India ink to ensure certain values. Such a drawing would be quite impossible of reproduction by the modern line process, for the camera ignores differences of tone due to dilution, and these can only be expressed by lines of different thickness and spacing.

POSTSCRIPT

Illustrations Nos. 378, 379, 380 are of work executed by students of the Training Department of the Goldsmiths' College, New Cross.

The first four bands on No. 378 are woven on hand-looms in the Handwork Section under the direction of Miss Bunnell; the patterns are quite simple and the direct result of the process.

The fifth example is simple needlework in wool on canvas, and in no way differs in principle from the woven patterns except that the pattern is an addition to—instead of—an integral part of the material; this with the examples shown in illustrations Nos. 379 and 380 is the work of students in the Art Section under the direction of Miss Dorothy Snow.

The patterns illustrated in No. 379 are in cross-stitch on linen, and notwithstanding the whimsical nature of the designs, are admirably adapted to the method of expression.

No. 380 is a sampler—an exploitation of various stitches, and patterns that may be evolved from them; though in the main direct and obvious, there is here and there evidence of licence, which, however, is permissible.

Much of the charm of the originals is in the colour, unavoidably lost in half-tone reproduction, but the purpose of illustration is to demonstrate patterns that can be readily achieved by simple methods which are well within the scope of the average executant.

No. 381 is an example of Swedish peasant weaving, and is interesting as a survival of traditional design.

In the foregoing patterns geometrical arrangement is conspicuous, due, indeed, to the process involved in each instance; this element, however, is not essential in No. 382, where the geometric character of the design is arbitrary and not necessary to the construction. The work is Arabian and is characteristic of Mohammedan design. It is part of a pulpit door, and consists of wood mouldings geometrically arranged, with relief detail in the enclosed areas.

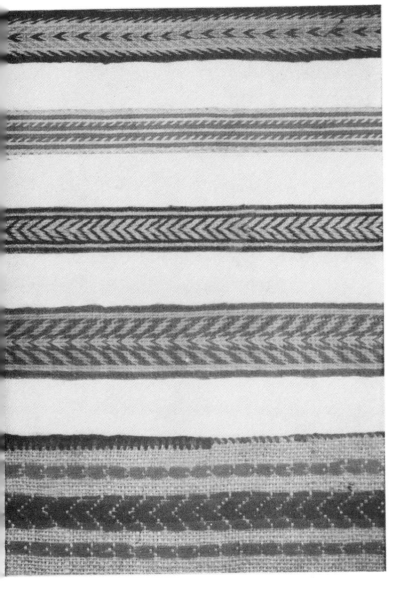

No. 378.

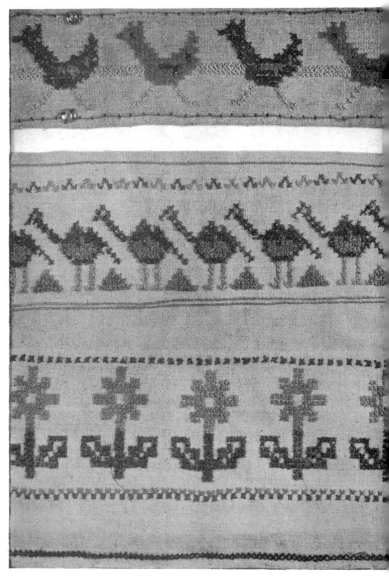

No. 379.

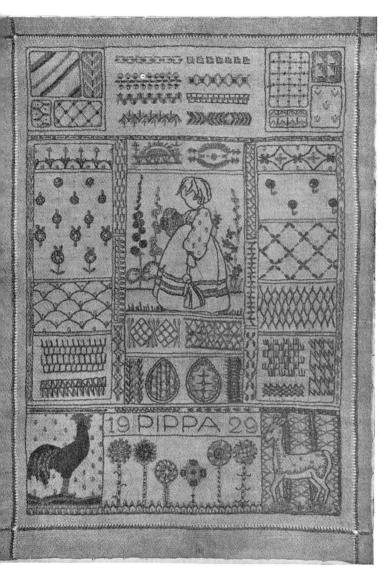

No. 380.

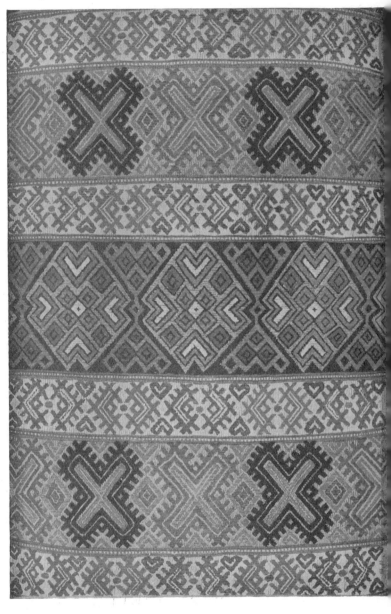

No. 381.

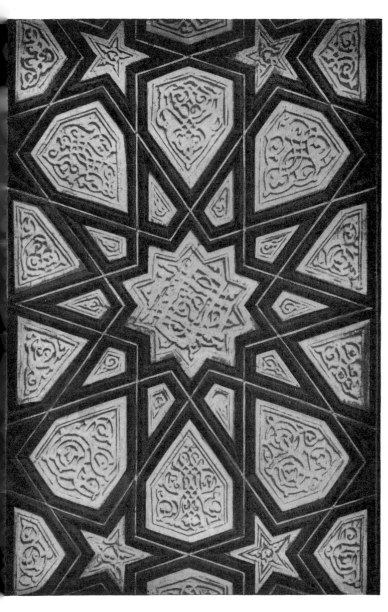

No. 382.

A CATALOG OF SELECTED
DOVER BOOKS
IN ALL FIELDS OF INTEREST

A CATALOG OF SELECTED DOVER
BOOKS IN ALL FIELDS OF INTEREST

CONCERNING THE SPIRITUAL IN ART, Wassily Kandinsky. Pioneering work by father of abstract art. Thoughts on color theory, nature of art. Analysis of earlier masters. 12 illustrations. 80pp. of text. 5⅜ x 8½. 23411-8 Pa. $4.95

ANIMALS: 1,419 Copyright-Free Illustrations of Mammals, Birds, Fish, Insects, etc., Jim Harter (ed.). Clear wood engravings present, in extremely lifelike poses, over 1,000 species of animals. One of the most extensive pictorial sourcebooks of its kind. Captions. Index. 284pp. 9 x 12. 23766-4 Pa. $14.95

CELTIC ART: The Methods of Construction, George Bain. Simple geometric techniques for making Celtic interlacements, spirals, Kells-type initials, animals, humans, etc. Over 500 illustrations. 160pp. 9 x 12. (USO) 22923-8 Pa. $9.95

AN ATLAS OF ANATOMY FOR ARTISTS, Fritz Schider. Most thorough reference work on art anatomy in the world. Hundreds of illustrations, including selections from works by Vesalius, Leonardo, Goya, Ingres, Michelangelo, others. 593 illustrations. 192pp. 7⅛ x 10¼. 20241-0 Pa. $9.95

CELTIC HAND STROKE-BY-STROKE (Irish Half-Uncial from "The Book of Kells"): An Arthur Baker Calligraphy Manual, Arthur Baker. Complete guide to creating each letter of the alphabet in distinctive Celtic manner. Covers hand position, strokes, pens, inks, paper, more. Illustrated. 48pp. 8¼ x 11. 24336-2 Pa. $3.95

EASY ORIGAMI, John Montroll. Charming collection of 32 projects (hat, cup, pelican, piano, swan, many more) specially designed for the novice origami hobbyist. Clearly illustrated easy-to-follow instructions insure that even beginning papercrafters will achieve successful results. 48pp. 8¼ x 11. 27298-2 Pa. $3.50

THE COMPLETE BOOK OF BIRDHOUSE CONSTRUCTION FOR WOODWORKERS, Scott D. Campbell. Detailed instructions, illustrations, tables. Also data on bird habitat and instinct patterns. Bibliography. 3 tables. 63 illustrations in 15 figures. 48pp. 5¼ x 8½. 24407-5 Pa. $2.50

BLOOMINGDALE'S ILLUSTRATED 1886 CATALOG: Fashions, Dry Goods and Housewares, Bloomingdale Brothers. Famed merchants' extremely rare catalog depicting about 1,700 products: clothing, housewares, firearms, dry goods, jewelry, more. Invaluable for dating, identifying vintage items. Also, copyright-free graphics for artists, designers. Co-published with Henry Ford Museum & Greenfield Village. 160pp. 8¼ x 11. 25780-0 Pa. $10.95

HISTORIC COSTUME IN PICTURES, Braun & Schneider. Over 1,450 costumed figures in clearly detailed engravings–from dawn of civilization to end of 19th century. Captions. Many folk costumes. 256pp. 8⅜ x 11¾. 23150-X Pa. $12.95

THE INFLUENCE OF SEA POWER UPON HISTORY, 1660–1783, A. T. Mahan. Influential classic of naval history and tactics still used as text in war colleges. First paperback edition. 4 maps. 24 battle plans. 640pp. 5⅜ x 8½. 25509-3 Pa. $14.95

THE STORY OF THE TITANIC AS TOLD BY ITS SURVIVORS, Jack Winocour (ed.). What it was really like. Panic, despair, shocking inefficiency, and a little heroism. More thrilling than any fictional account. 26 illustrations. 320pp. 5⅜ x 8½. 20610-6 Pa. $8.95

FAIRY AND FOLK TALES OF THE IRISH PEASANTRY, William Butler Yeats (ed.). Treasury of 64 tales from the twilight world of Celtic myth and legend: "The Soul Cages," "The Kildare Pooka," "King O'Toole and his Goose," many more. Introduction and Notes by W. B. Yeats. 352pp. 5⅜ x 8½. 26941-8 Pa. $8.95

BUDDHIST MAHAYANA TEXTS, E. B. Cowell and Others (eds.). Superb, accurate translations of basic documents in Mahayana Buddhism, highly important in history of religions. The Buddha-karita of Asvaghosha, Larger Sukhavativyuha, more. 448pp. 5⅜ x 8½. 25552-2 Pa. $12.95

ONE TWO THREE . . . INFINITY: Facts and Speculations of Science, George Gamow. Great physicist's fascinating, readable overview of contemporary science: number theory, relativity, fourth dimension, entropy, genes, atomic structure, much more. 128 illustrations. Index. 352pp. 5⅜ x 8½. 25664-2 Pa. $8.95

ENGINEERING IN HISTORY, Richard Shelton Kirby, et al. Broad, nontechnical survey of history's major technological advances: birth of Greek science, industrial revolution, electricity and applied science, 20th-century automation, much more. 181 illustrations. ". . . excellent . . ."–*Isis*. Bibliography. vii + 530pp. 5⅜ x 8¼. 26412-2 Pa. $14.95

DALÍ ON MODERN ART: The Cuckolds of Antiquated Modern Art, Salvador Dalí. Influential painter skewers modern art and its practitioners. Outrageous evaluations of Picasso, Cézanne, Turner, more. 15 renderings of paintings discussed. 44 calligraphic decorations by Dalí. 96pp. 5⅜ x 8½. (USO) 29220-7 Pa. $4.95

ANTIQUE PLAYING CARDS: A Pictorial History, Henry René D'Allemagne. Over 900 elaborate, decorative images from rare playing cards (14th–20th centuries): Bacchus, death, dancing dogs, hunting scenes, royal coats of arms, players cheating, much more. 96pp. 9¼ x 12¼. 29265-7 Pa. $12.95

MAKING FURNITURE MASTERPIECES: 30 Projects with Measured Drawings, Franklin H. Gottshall. Step-by-step instructions, illustrations for constructing handsome, useful pieces, among them a Sheraton desk, Chippendale chair, Spanish desk, Queen Anne table and a William and Mary dressing mirror. 224pp. 8⅛ x 11¼. 29338-6 Pa. $13.95

THE FOSSIL BOOK: A Record of Prehistoric Life, Patricia V. Rich et al. Profusely illustrated definitive guide covers everything from single-celled organisms and dinosaurs to birds and mammals and the interplay between climate and man. Over 1,500 illustrations. 760pp. 7½ x 10⅛. 29371-8 Pa. $29.95

Prices subject to change without notice.

Available at your book dealer or write for free catalog to Dept. GI, Dover Publications, Inc., 31 East 2nd St., Mineola, N.Y. 11501. Dover publishes more than 500 books each year on science, elementary and advanced mathematics, biology, music, art, literary history, social sciences and other areas.